IMAGES
of America

HOOVER

'GO FORWARD

VOTE <u>YES</u>

TO

Incorporate

HOOVER

To Incorporate? It is the late 1960s, and there are many reasons to vote "yes" or "no" to incorporate. Some people were concerned about tax burdens on the residential area, and there were disagreements on what to name the town; still, others saw potential. After two votes (in 1964 and 1967), the area officially became the town of Hoover in 1967. It gained city status in 1973. (Courtesy of Hoover Service Club, Hoover Historical Society.)

On the Cover: Early Montgomery Highway, 1920. Highway 31 twists and turns through Hoover and other neighboring cities. Today, it is a paved, modern road that is heavily traveled. Take a look at this family heading down the road so many years before modern times changed this highway heading into Hoover. (Courtesy of the Birmingham, Ala, Public Library Archives.)

IMAGES
of America

HOOVER

Heather Jones Skaggs

ARCADIA
PUBLISHING

Published by Arcadia Publishing
Charleston, South Carolina

Printed in the United States of America

Library of Congress Control Number: 2014945509

For all general information, please contact Arcadia Publishing:
Telephone 843-853-2070
Fax 843-853-0044
E-mail sales@arcadiapublishing.com
For customer service and orders:
Toll-Free 1-888-313-2665

Visit us on the Internet at www.arcadiapublishing.com

"I hope Hoover will continue to grow as a good, clean city, one that emphasizes quality not size," William H. Hoover, *in the* Hoover Sun, *November 20, 1974.*

CONTENTS

ACKNOWLEDGMENTS

This was a big project with a lot of sources for photograph and information. I hope I have not left anyone out, but I am sure I have missed someone. To all who have helped, thank you.

Thank you to my family: my husband Greg Skaggs; Bill and Donna Jones, Hunter and Meg Jones, Aunt Fran and Uncle Jim, Keith and Kay Milam, and Rosemary and Tony Skaggs. Thank you to Eileen Lewis; Susanne Wright; Anna Lu Hemphill; Jacqueline Hall; Lynda Wasden; Nancy Brasher; Torrencie Bailey; the Whitworths; Roberta Atkinson; Jan Greer; Sara Perry; Mary Ross Searcy; Sally Johnson; Faye and John Anderson; Frank Skinner; Jane Hoover Parish; Helen Hoover Holmes; Thomas Hoover; Jason Gaston, Mary Jo Powell, and the Hoover Board of Education; Kay and Eddie Aldridge; Jack Wright; coach Wayne Wood; Johnny Jones; Daniel Moore; Squire Guin; and Karen King. A special thanks to library director Linda R. Andrews, Anissa Copes, and current and former members of the Hoover Public Library staff and board. Thanks to William Gresham, of the Hoover Fire Department, and Captain Coker, of the Hoover Police Department. Thank you to my friends the Tyler family: Bobbie Tyler Hill who sat and scanned with me and Hale/Bluff Park historian Susan Hale Copeland Kelley—my great friend. Thanks goes to Linda Nelson and the Jefferson County Historical Commission, Don Veasey and the staff at the Linn Henley Research Library, Charlotte Patton of the Hoover Historical Society, the mayor's office and city council, and Lori Salter, who dug through city hall for photographs.

INTRODUCTION

The city of Hoover dates back to the 1950s and 1960s, with a small community in the bustling and growing area located in both Jefferson and Shelby Counties in Alabama. Although Hoover is a fairly young city, its communities date back to the 1900s or earlier. This pictorial will offer a sampling of historical aspects of Hoover through its founder, schools, churches, and government. Today, the city is very large, so this book will only focus on the five areas known as Bluff Park, Green Valley, Shades Mountain, Patton (or Patton's) Chapel, and Rocky Ridge.

The beginning of Patton Chapel is traced back to Robert Berry Patton from Tennessee, who first came to Alabama in the 1840s and lived in Elyton. After his wife died and he had remarried, he moved to the area that would become the center of where the future city of Hoover would develop and grow in the 1850s. Patton is credited with establishing the community of Patton Chapel. He built a water-powered sawmill on the creek below Portsmouth Drive. His land grant was approximately 320 acres, with an additional 40 acres allocated for his sawmill on the creek. Other members of the Patton family that moved to the area included Matthew, Samuel, and William G. Patton. Later, a nephew, Thomas G., moved and joined the family. The settlers also built a church and school for their community. Many of the Pattons are buried in the historical cemetery located on Patton Chapel Road.

Bluff Park and the area known as Shades Mountain are some of the oldest communities in Hoover. Over 100 years ago, Bluff Park was a vacation and health resort with natural spring waters flowing out of the mountain. Before the area was known as Bluff Park, it was called Spencer Springs after Octavius Spencer. The name changed again in 1863, when Gardner Hale of Prattville purchased the property. Hale kept the land as a resort area and renamed it Hale Springs. In 1892, the Hale Lumber Company built an access road over an old wagon trail to transport lumber. This road gave resort visitors a way to get up and down the mountain from Oxmoor Valley. As time passed, visitors and landowners of Hale Springs became more interested in the view from the bluff rather than the springs and their healing properties. It was around this time that the name Hale Springs changed to Bluff Park, which grew and changed from a resort area to a historic residential community. A complete history of Bluff Park can be found in Images of America: *Bluff Park*. Shades Mountain Elementary School, located a few miles away but still in the mountain community, was established in 1961–1962. It was built as a county school and later became part of the Hoover City Schools system when it was formed.

According to the Acton family history, Rev. Robert Bailey conducted services in a brush arbor in the Rocky Ridge community around 1853, resulting in the organization of the Rocky Ridge Cumberland Presbyterian Church in 1854. There are three households of note listed in early census notes: those of John Acton, Samuel Acton, and Thomas L. Bailey. It was from these families and their descendants that the Rocky Ridge community was born. In 1881, land was deeded for a school, and a schoolhouse was built. A three-room school was built to replace the older facility in 1927. The present building, which opened in 1966, has gone through several stages of remodeling since becoming part of the Hoover City Schools system.

The community of Green Valley voted to incorporate into the town of Green Valley with the hope of avoiding joining the newly formed Hoover, but as decisions were overturned, all of the area was eventually incorporated into Hoover. Today, the community of Green Valley stretches over a larger area than in its early years. Green Valley Elementary School, Green Valley–Hoover Country Club, and the original location of Employers Insurance are all located in the Green Valley community. The Parade of Homes also started in this area, and one home on Valgreen Lane was one of the original homes on the tour when it was built. Star Lake, also located in the Green Valley community, was annexed in 1969.

William Henry Hoover Sr., of Russellville, Alabama, set out the monumental task of forming Employers Mutual Insurance of Alabama in 1921, and he did it without a salary. In October 1922, the first board meeting was held at the Tutwiler Hotel in Birmingham. Attending this meeting was a group of prominent Birmingham men, such as W.H. Stockham, F.M. Thompson, and Dr. W. Earle Drennen. On December 2, 1922, Employers Mutual of Alabama was open for business. In its first year, the company operated from a cramped one-room office in downtown Birmingham. The company emerged from the Depression as one of the most sound casualty companies in the nation. In 1929, the company was converted from a mutual company to a stock company, now the Employers Insurance Company of Alabama, Inc. In the 1930s, Hoover Sr.'s brothers Daniel V.S. Hoover and George Washington Hoover came and joined the company. Later on, in their adult life, William's sons started their careers with the company. Employers Life Insurance Company was formed in 1944. That same year, Hoover Sr. purchased 160 acres on what is now Tyler Road. The dirt-logging road would soon be the land where Hoover Sr. would build his family home. Hoover Sr., quite the visionary, began buying land on Highway 31 under the name South Jefferson Company in the 1950s after learning of the state's plan to start widening Highway 31. He realized the movement south would bring opportunity to the area. This area became known as the Hoover community. The ground breaking for Employers Insurance Company of Alabama's new home-office building in the community was in December 1957, and it was completed in September 1958. It was from this building that the rest of the city's businesses began to spring up. It can be said that the city of Hoover, Alabama, started there. In 1959, Hoover Sr. provided land for the development of a golf course and country club he envisioned on undeveloped ground. Green Valley–Hoover Country Club was built near Star Lake in the Green Valley community. The Hoover Volunteer Fire Department was formed and incorporated in May 1962. The newly formed fire department needed a fire chief, and Ralph Sheppard was chosen for the honor. Once the chief was appointed, the department was ready to purchase a pumper, a 1944 Mack model. Annual fire dues from residents in the district were $15. Hoover Sr. offered land behind Employers Insurance to store equipment, and this became Hoover Fire Station No. 1, which is still in use today. The department continued as both paid and volunteer until 1976, when it grew to 19 paid employees.

The earliest garden club on record is Shades Crest Garden Club, organized in 1935. The Hoover Civic Club, formed in 1965, printed one of the first telephone directories for the community. More clubs and organizations formed as the population of the residential area grew. The Shady Brook Garden Club organized in 1952, and the Rock N Dale Garden Club organized in 1956. The Star Lake Garden Club organized in 1961, the Deo Dara Garden Club formed around 1962, and the Patton Chapel Civic Club was founded in 1965. The Hoover Lions Club was founded in 1966, and the Shades Mountain Optimist Club formed in 1968. As the community grew, the need to incorporate became apparent for many reasons, with one being police protection. In December 1964, the first vote was held to officially incorporate the residential areas into the town of Hoover, but it was voted down. Another vote was taken in April 1967, and this time, the area incorporated was smaller (only four blocks long and one block wide); the vote passed. What some refer to as "old Hoover" is the original area that was first incorporated. It includes Whispering Pines, Helen Circle, part of Deo Dara Drive, Greenvale Road, and Valgreen Lane. The population of the new town was 406 people. The incorporation and, later, annexations were not without bumps in the road. There were controversies and questions of legality that played out in the newspapers, but in the end, the town (and then city) of Hoover was officially created.

Part of Green Valley incorporated itself to keep from being annexed, but that voting legally fell apart. Other annexations included (but not limited to) Patton Chapel and Chapel Hill annexing in May 1970, and in June it was contested. Bluff Park was annexed into the city of Hoover in 1985. Although some annexation of Bluff Park started in 1975, it was stopped by a restraining order due to fire district issues. Rocky Ridge was under the eye of Vestavia Hills, as was Bluff Park for some time. A petition was started to have Vestavia incorporate Rocky Ridge around 1976, but the city was not sure if it could carry the load of new residents on city services. Hoover then made the move to incorporate the area. As a result, some of Rocky Ridge is part of Hoover and some is Jefferson County.

So, the city pressed on, adding more residential and commercial areas to its growing map. The first motel chain in Hoover was the Holiday Inn in 1964, located a few blocks from Interstate 65. It stopped the property line of Vestavia Hills from moving forward. Hoover city officials first met in a building on land that was part of Hoover Sr.'s property on Highway 31. The structure still stands with other businesses now occupying it today. A new city hall was built in 1985 several blocks down Highway 31 from the original city hall (which only had two jail cells). Jack Harrison was hired as the town/city attorney, and the city's first clerk was Anita Steiner. Hoover needed a police department, and it was formed in 1967 with James R. Norrell as its first police chief. Oscar Davis joined the force and was named chief after Norrell retired. The first police cruiser was a 1968 Ford Galaxy. David Cummings joined the Hoover Police force in 1972 and would later become chief. In the mid- to late 1980s, the Hoover Police Department grew from 33 officers to 68 officers.

The Hoover Beautification Board was formed in 1977. Also established were the Hoover Chamber of Commerce in 1978 and both the Hoover Industrial Board and the Hoover Masonic Lodge in 1981. Hoover later decided to start its own school system in 1988. A significant change to the city occurred when Interstate 459 opened a major interchange with Interstate 65 in the city. In 1982, the Hoover Public Library opened in its first location with 8,000 books and materials in the collection. The annexation of Riverchase was extremely beneficial, and the city enjoyed tremendous residential and commercial growth throughout the 1980s. In 1986, Riverchase Galleria complex opened and increased the tax revenue and jobs in the city. The Hoover Metropolitan Stadium opened in 1988 with a sellout crowd. The Met (also called Regions Park for a short time) was the home of the Birmingham Barons from 1988 to 2012. It can convert to a football field and has been used for beach volleyball, soccer, concerts, workshops, and more.

Along Highway 31, many businesses were established. The Big Green Cleaning Machine stood with a Texaco gas station. Hoover Court was the first shopping center established in the community, around 1961. Shopping centers like Hoover Square (with T.J. Maxx), where the first movie theater was located, Hoover Village, Golbro Center (now Ellis Piano), and the Hoover Mall (now Hoover Commons) also opened. Telvue Cable Television founder Mr. Victory brought his business to Hoover and turned on the first cable customer in 1967 after the FCC freeze was lifted. Some of William Hoover's plans for property he purchased never came to fruition. There are still a few existing copies of a brochure on a regional shopping center to be located on 59 acres with an eight-story office tower and covered mall area at its center. It was to be where Don Drennen and Ivan Leonard dealerships are located, but it never got off the ground.

Hoover is the home of several celebrities, including Miss America 1995, Heather Whitestone, who went to Berry High School; Miss America 2005, Deidra Downs, a former student at Simmons Middle School; American Idol Taylor Hicks; artist Daniel Moore; and Will Pearson, a founder of *Mental Floss* magazine.

Today, Hoover has grown to a total area of 43.65 square miles, much larger than its original four blocks, and is home to some of the top schools in the state. Hoover is also one of the first municipalities using state-of-the-art biofuel in its city vehicles. It is important to see where the town was as a young city to continue on the right path, survive difficult times, and grow not only as a great city, but as a place where families and friends—young and old—will gather for years and call Hoover home. Welcome to Hoover, Alabama.

One

THE HOOVER FAMILY

WHERE THE VISION BEGAN

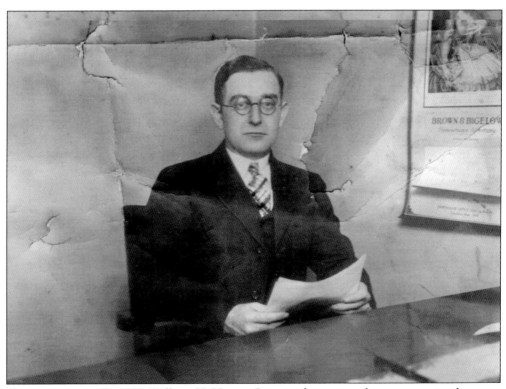

THE PHARMACIST. In 1910, William H. Hoover Sr. started correspondence courses in pharmacy school. He worked at Gunns Drug Store in Bessemer. When the store closed, he studied and used the store to learn about pharmaceuticals. The hard work paid off, and Hoover Sr. became a licensed pharmacist. Due to a loss of hearing, though, he realized he would have to pursue another line of work. (Courtesy of Jane Hoover Parrish.)

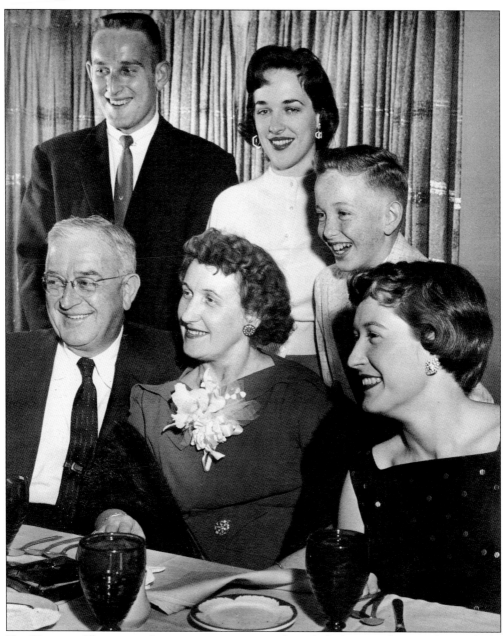

THE HOOVERS. There is no other way to start a journey through the history of Hoover than with the man himself. Hoover Sr. was not only a business and family man, but also a man of great character, personality, and vision. His father had a brick-manufacturing business near Russellville, and it was his intention to build a town for the workmen and name it Hooverville. When it did not happen, it became the lifelong dream of his son to make it a reality. This vision of a town to carry his family name and fulfill the dream of his father started with the courage, planning, and foresight to step out and start his own business in 1922. Pictured here, at The Club for an anniversary dinner, are William Henry Hoover Sr. (1890–1979) and his wife, Helen Carnes Hoover (1902–1987), with their children, from left to right, Bill Hoover Jr. (1936–2009), Helen Hoover Holmes, Thomas Herbert Hoover, and Jane Hoover Parrish. (Courtesy of Jane Hoover Parrish.)

JANE, HELEN, AND THOMAS HOOVER.
Jane Hoover Parrish, pictured at right, is the first daughter of William Henry and Helen Hoover. "My father always took time for us to do things together as a family. He was the wheel, and my mother, the hub," said Jane. She married Tom Parrish, and their children are Clayton, Douglas, Lynn, Tom, and William Blair. Sister Helen, pictured below with her brother Thomas, married Derrell Holmes, and their children are Elizabeth, Leslie, and Derrell Jr. Thomas, the youngest, married Dottie Goodwin, and their daughter is AnneMarie. Thomas was also the president of Employers Life Insurance company. The painting seen here is of their father, William Henry Hoover Sr. (At right, courtesy of Jane Hoover Parrish; below, author's collection.)

WILLIAM H. "BILL" HOOVER JR. (1936–2009). Bill Hoover Jr. (twin brother of Helen Hoover Holmes) married Julie Gunn, his wife of 50 years, and had one child: William Henry Hoover III (1963–2009). Bill joined the family business at Employers Insurance after college and had a long and successful career with the company, retiring as president and chairman of the board. An avid golfer, he enjoyed playing many rounds of golf at Green Valley–Hoover Country Club and was one of the past club presidents. When his father, William, passed away, his club number, no. 1, was passed to Bill. Bill is quoted as saying that it was a great honor and with great pride that he used his father's number. It was estimated by Bill that he played many thousands of rounds at the club. Bill Hoover Jr. passed away in February 2009 after a long battle with cancer. (Courtesy of Hoover County Club.)

Three Hoover Brothers. William Henry Hoover Sr., right, had two brothers who later joined him in his business along with his sons. Daniel V.S. Hoover (1888–1971), known as "V.," is at left and standing is "General" George Washington Hoover (1873–1976). All of the Hoover brothers were born in Russellville. The name *Hoover* comes from an old German word "Hube," which developed into Huber and then changed to the current spelling of Hoover by immigrants in the 1700s. The word *hube* means a possessor of a tract of land. After William Hoover's pharmacy career came to an end, he entered the insurance business in 1912, mostly selling accident and health insurance for Continental Casualty. In 1922, he started the monumental process of forming Employers Mutual of Alabama while working alone and without a salary. (Courtesy of Jane Hoover Parrish.)

HOOVER HOME. In 1944, William Hoover Sr. bought 160 acres on Tyler Road, where he would later build his family home in 1950. Tyler was a narrow dirt road at the time with little to no neighbors. A small general store, McAllister's on Shades Crest, was where the Hoovers would stop for food and supplies before driving to their house, a two-room log cabin built from lumber that was cut and dressed at nearby Sellers Saw Mill. The Hoover family home took two years to build due to shortages of supplies, but in February 1950, they moved into their new home. The Hoover family home was annexed into the city of Hoover in April 1975. It is listed on the Alabama Register of Landmarks and Heritage as the Hoover-Randle Home. (Above, courtesy of Jane Hoover Parrish; below, Barbara Randle.)

Two

EARLY CHURCHES

FAITHFUL BEGINNINGS

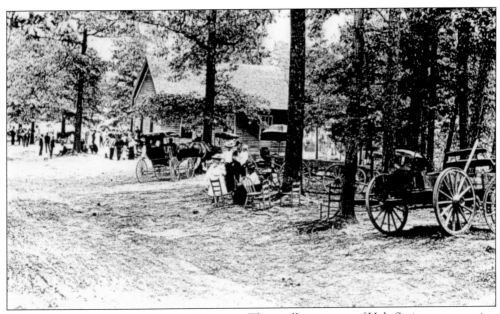

THE FIRST CHURCHES OF BLUFF PARK, HOOVER. The small resort area of Hale Springs was growing into a residential community that would later be called Bluff Park. One of the first churches built in this area was Summit Church and School. This 1910 photograph shows what is thought to be the Hale family, in the center, gathering for a picnic at church. (Courtesy of Tommy Tucker.)

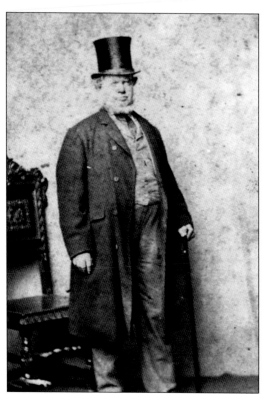

FOUNDERS OF BLUFF PARK. Gardner Cole Hale (left) and his wife, Ann Susan Ballou, are credited with the founding of Hale Springs–Bluff Park. Between 1859 and 1863, Hale purchased property on Shades Mountain, which was a resort area. Below, Daniel Pratt Hale (1849–1922) was the 10th child of Ann Susan Ballou and Gardner Cole Hale. Pratt and his wife, Annie Marshall Kirkland, had six children and lived on Shades Crest Road like the rest of the family. The original home of D.P. Hale was on the site of 713 Shades Crest Road. The original barn on the property was a place of worship where the faithful started to grow. (Both courtesy of Susan H.C. Kelley.)

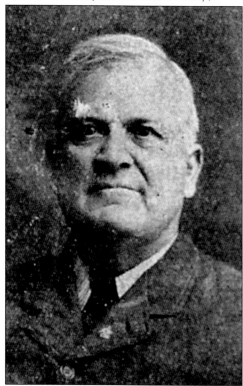

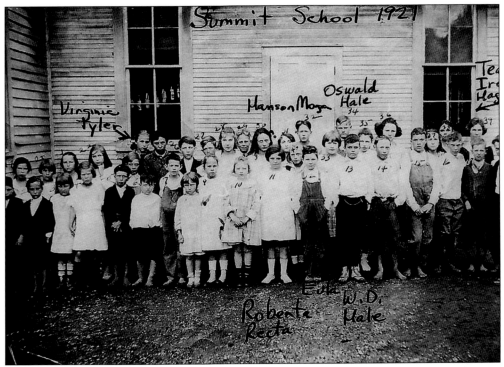

SUMMIT SCHOOL–BLUFF PARK BAPTIST CHURCH. Pictured above are children standing in front of the original Summit Church and School, one of the first churches in Bluff Park pastored by F.H. Watkins. In 1921, the church voted to change its name to Bluff Park Baptist Church. Summit School moved to a new location. Seen below on some of the rock formations near the church is the WMU women's group, including Mrs. W.M. Tyler, Mrs. Chambers, Mrs. E.W. Morris, Mrs. H.G. Stokes, Mrs. Armstrong, Mrs. W. Williams, Ethel Hale, B.C. Chairsrlleand, and Mrs. Dison-Moore. (Above, courtesy of Susan H.C. Kelley; below, Bluff Park Baptist Church.)

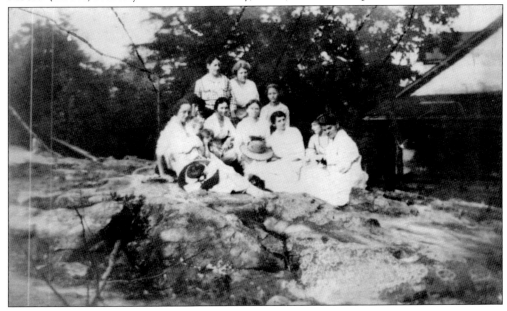

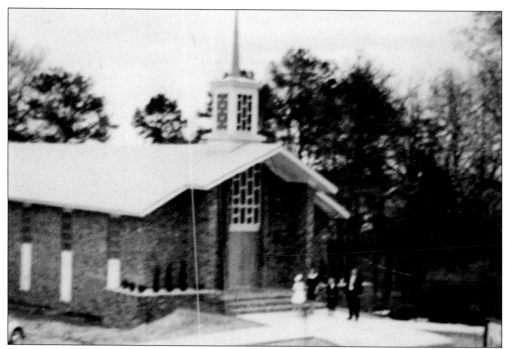

BLUFF PARK BAPTIST, 1967. Pictured above is Bluff Park Baptist Church when it was located at the corner of Valley Street and Alford Avenue. The church stood at this location until the early 1970s. It was remodeled, used by several groups, and later became the home of St. Luke's Korean Catholic Church. In 1973, plans began for a new building at a new site just a few blocks from the original location. Ground-breaking ceremonies were held on December 16, 1973, for the new church on McGwier Drive. Below is an image from a year later, in 1974, as the congregation leaves the church on the last day in the old church building on Valley Street. Services at the new location on McGwier Drive started soon after. (Both courtesy of Bluff Park Baptist Church.)

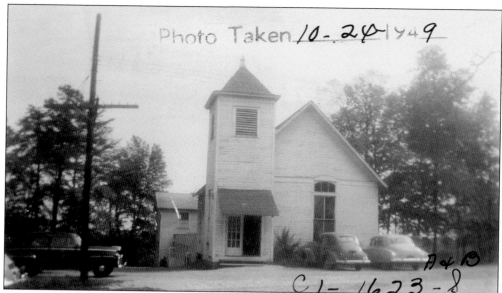

BLUFF PARK UNITED METHODIST CHURCH. In 1905, some local women formed the Ladies Aid Society to raise funds to start a Methodist church, which began in 1908. The group and other denominations met at a barn on the property of Daniel Pratt Hale and later moved to their new location. Pictured above in 1949 is Bluff Park United Methodist Church's first building, constructed in 1912 in 12 days. The image is one of only two known photographs of the structure still in existence. After additions in the 1970s, a new building program was started for construction of the third sanctuary in 1999. Senior minister Reid Crotty retired after 22 years at Bluff Park United Methodist Church, and his last sermon was on Sunday, June 9, 2013. Leading the church today is senior pastor Mike Holly and associate minister Peter von Herrmann. (Above, courtesy of Birmingham, Ala, Public Library Archives; below, bluffparkal.org.)

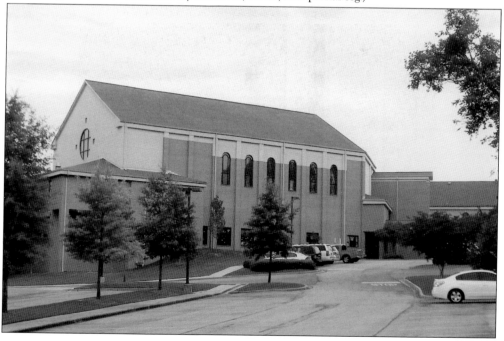

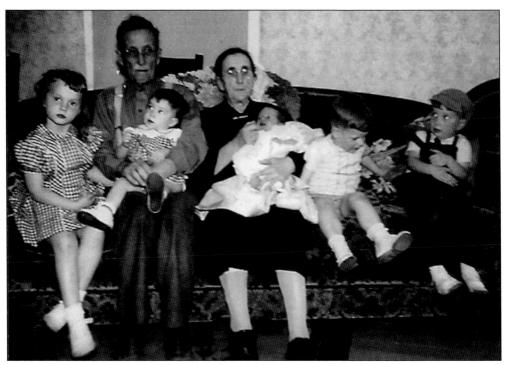

THE TYLER FAMILY AND BLUFF PARK. Joe "Jobe" Tyler, one of the Tyler brothers who ran the family dairy farm, was instrumental in bringing lumber up to Shades Mountain so that Bluff Park United Methodist Church could be built. The photograph above, taken in April 1944, shows the Jobe Tyler family. Sitting with their grandfather Jobe are Bobbie Tyler Hill in his lap and sister Sandra Tyler Ridgeway on the far left. The other children are Tyler cousins. Pictured below in an earlier family image are, from left to right, Jobe's son Robert Scott Tyler, along with Gladys, James, Virginia, Margaret, Florence Tyler, Joe Tyler, Alice, and Charlie. (Both courtesy of Bobbie Tyler Hill.)

JOBE'S SON, ROBERT SCOTT TYLER.
Robert Scott Tyler (1917–2007) is seen
at right with his wife, Garnette Cox
Tyler, of Leeds, Alabama. Robert,
the youngest of Jobe's children, was
raised on the family dairy farm in
Bluff Park with his siblings James,
Charlie, Gladys, Alice, Margaret,
and Virginia. Robert had the honor
of being one of the "oldest" members
of Bluff Park United Methodist
Church—not through age but length
of membership. Below is a younger
Robert in his Navy uniform. He
was also a volunteer fireman for the
Bluff Park Fire Department, and he
worked almost up to until his death
in the hardware business. He was
honored by the *Birmingham News* on
his 90th birthday, and February 14,
2007, was named "Robert Tyler Day"
by the city of Homewood, Alabama.
(Both courtesy of Bobbie Tyler Hill.)

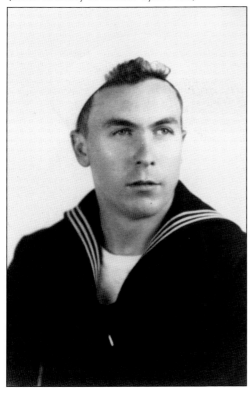

SHADES CREST BAPTIST CHURCH. This church started in May 1954 in the Bluff Park School cafeteria. Its first pastor, Rev. John Norman of Fairfield, was called to head the church. The next year, the church moved to Park Avenue. A ground breaking for the Rockland Building began in March 1955. In 1967, Shades Crest Baptist Church dedicated its new sanctuary. Rising above the steeple is a beautiful cross. (Courtesy of bluffparkal.org.)

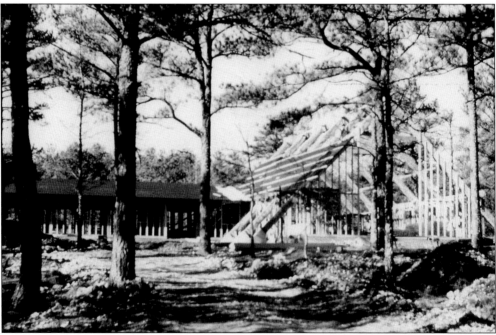

ST. ALBAN'S EPISCOPAL CHURCH. Bishop George Murray purchased land in Bluff Park in 1960. Several Episcopalians who supported an idea for a church in Bluff Park met at the community center in 1961. In October of that year, ground-breaking ceremonies were held, and Bishop Murray broke the first patch of earth. The completed building was dedicated on March 17, 1963. The first vicar was Rev. Charles Horn. (Courtesy of St. Alban's.)

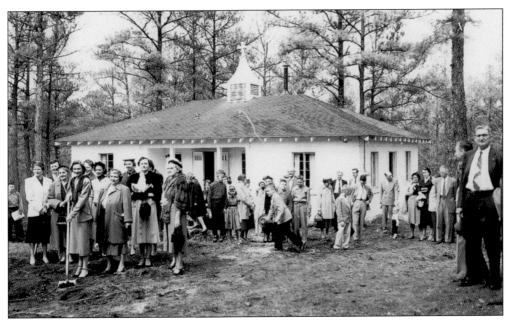

CHAPEL IN THE PINES. In this March 1950 photograph, members of Chapel in the Pines Presbyterian break ground for the site of their church. A lot was donated by C.H. Chichester and Associates. Finished in one month, the name was provided by a young girl named Sandra Evans. The chapel was ordained and dedicated on Mother's Day in 1950 with 53 charter members and its first pastor, Robert Montgomery. (Courtesy of Chapel in the Pines.)

SHADES MOUNTAIN CHURCH OF CHRIST. In 1958, Homewood Church of Christ purchased property on Shades Mountain. Forty families, led by Bill Baxley and Jim Gambill, established Shades Mountain Church of Christ. In 1960, they met at Bluff Park Community Center. A year later, the congregation moved into its new (and current) building on Alford Avenue. The first preacher was Robert Turner, and Franklin Camp served from 1962 to 1972. (Author's collection.)

SHADES MOUNTAIN INDEPENDENT CHURCH AND SCHOOL. In 1969, people started gathering in a local insurance building to hear Dr. Richard H. "Dick" Vigneulle (at left) share his testimony. In 1970, Vigneulle was ordained, and the church group continued growing. This was the beginning of Shades Mountain Independent Church and School. Vigneulle continued as lay pastor and then as full-time pastor. Church leaders started looking for a site to build on, and one area on Tyler Road got their attention. The property, owned by U.S. Steel, was not for sale but was a perfect location. They stepped out on faith, submitted a bid, and got the contract. Ground breaking for the church was on September 19, 1971, and was completed in 1972. Vigneulle passed away on September 5, 2013. (Both courtesy of Shades Mountain Independent Church and School.)

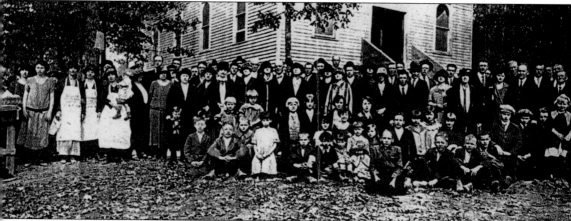

ROCKY RIDGE CUMBERLAND PRESBYTERIAN CHURCH. According to Acton family history, Rev. Robert Bailey conducted services in a brush arbor in the Rocky Ridge community around 1853, resulting in the organization of the Rocky Ridge Cumberland Presbyterian Church in 1854. The 11 charter members were John V. Acton, Passa D. Acton, William Acton, Elizabeth Acton, Z.W.H. Acton, Kitsey Jane Armstrong, Zelphia Levi Armstrong, Daniel Watkins, Drucilla Watkins, Martha Watkins, and S.H. Watkins. Robert Bailey and Emerson Acton were the first ministers that aided in the organization. The first building, made of logs, was near what is now AAA Insurance. Each month, Rev. George M. Simpson, a circuit preacher, would come and preach. Simpson is believed to be the first paid, full-time minister for the church. He was paid with room and board and chicken, ham, or canned foods. In the 1880s, the original log building burned, and a new one-room church was built across the street from the original location around 1914. This image is from 1920. (Courtesy of Rocky Ridge Cumberland Presbyterian Church.)

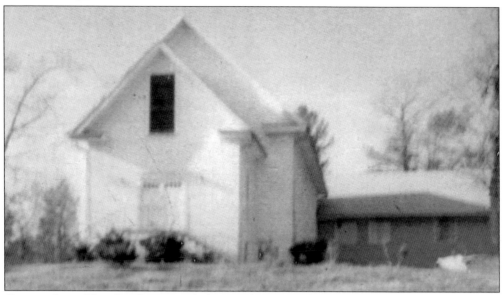

CHURCH LIFE. The church, pictured above in later years (1961), had a potbellied stove in the middle of the room to provide a warm fire during the colder months. A small spring on what is now Acton Road was used to bring in water with a pitcher for drinking and also for baptisms. Below, the 1930s and 1940s were tough times economically, but the church was full of life with annual Sunday singings, children's programs, and Christmas programs. Shown here in March 1947 is the annual "Second Sunday Sing." It was a packed house of worship for the event. Major growth in the church happened in these times and all in a little one-room structure. (Both courtesy of Rocky Ridge Cumberland Presbyterian Church.)

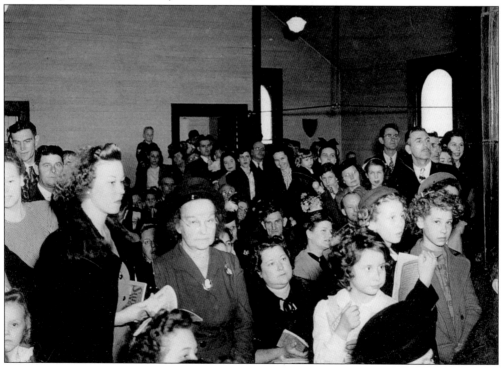

ALTADENA VALLEY PRESBYTERIAN CHURCH. Founded in 1854 as Rocky Ridge Cumberland Presbyterian Church, in 1912 there was a split over whether or not the church should maintain its affiliation with the Cumberland Presbyterian denomination or establish a new affiliation with the northern Presbyterian Church. The group that moved to the church's current location chose to be members of the northern Presbyterian Church. The church was named Acton Memorial Church, in honor of Zephaniah William Henry Acton, a charter member and founder of the original church. The Acton name was prominent among the membership in those days. The church began to grow in the late 1960s, and the name was changed in 1968 to its current name of Altadena Valley Presbyterian Church. Several building programs were initiated and completed during the 1970s and early 1980s, including the 1983 razing of the old sanctuary and the construction of the current sanctuary as a replica of that old building. On June 4, 1978, the congregation voted unanimously to change its denominational affiliation to the PCA (Presbyterian Church in America). (Author's collection.)

BRIARWOOD PRESBYTERIAN CHURCH. This church, which now calls the Rocky Ridge/Acton area home, was formed in 1960 in Cahaba Heights by Rev. Frank M. Barker Jr. In September 1963, the church moved to a new location on Highway 280. Pictured above is the early Highway 280 facility. The church organized Briarwood Christian School in 1965, and in 1972 the Briarwood Theological Seminary was chartered. Years later, in 1988, the church moved to the Acton Road area, shown below. In 1999, after serving as pastor for 40 years, Dr. Barker became pastor emeritus, and Dr. Harry L. Reeder III became senior pastor. The Youth Barn opened on May 11, 2012, for youth ministries and events, and the Children's Auditorium addition opened on Easter Sunday in March 2013. (Courtesy of Briarwood Presbyterian Church.)

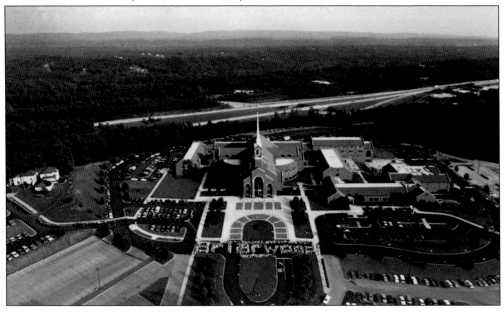

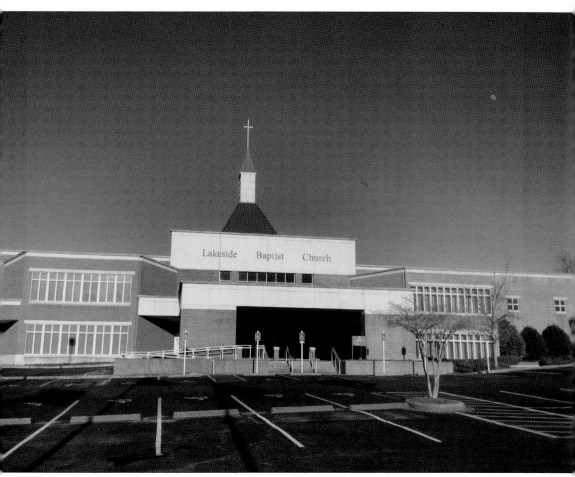

LAKESIDE BAPTIST. Lakeside began as a mission sponsored by Shades Mountain Baptist in 1957. First meeting at Rocky Ridge Elementary, Julian Yuille served as pastor. The church name was suggested by one of its first members, R.B. Reid. A permanent church home was constructed on property adjoining Lake Cahaba. In 1957, the congregation approved the name Lakeside Baptist Mission, which became Lakeside Baptist Church in 1958. Ground breaking for the new church was on October 5, 1958. The first leaders were Rev. Julian Yuille, pastor; H.G. Youngblood, chairman of deacons; Herbert Vines, chairman of finance; and Fletcher Nottingham, building chairman. Lakeside Kindergarten was established in 1961, and Mabel Lewis was director of the kindergarten program. The first addition to the building was in 1962, and it was dedicated on September 30, 1962. The second addition was completed in April 1966. Today, the church property includes a worship center, three areas of educational space, a children's wing, and a gym. (Author's collection.)

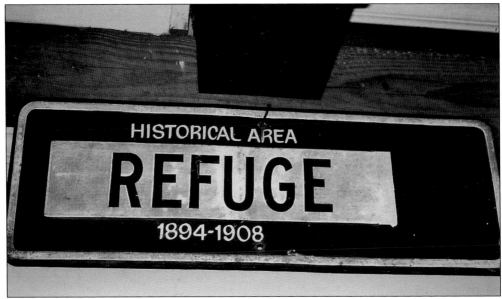

PATTON CHAPEL. Refuge is believed to be the name of the community centered around Patton Chapel Church until 1908. The sign above was found by Gilbert Douglas Jr. on his property in the area. The name *Refuge* is also noted on a 1905 topographical map that shows the location of Patton Chapel Church and School. Robert Berry Patton used timber he cut at his sawmill to build the community its own church, which would carry his name. Patton Chapel Church and School was built on land where Hoover First United Methodist Church stands today. Patton became an ordained deacon and served as its local minister. The church building burned to the ground in 1908, and another building burned in 1938. The plaque below was positioned at the historic site by the Hoover Historical Society. (Above, courtesy of Gilbert Douglas; below, author's collection.)

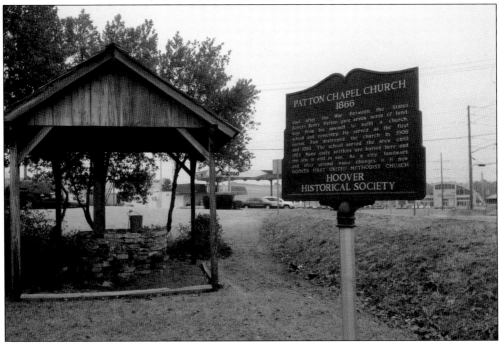

Pastor Gerald Duncan. At right, Pastor Gerald Duncan (1949–1956) holds Jenny and Gerald King for their christening day in 1951. The congregation's third church building was a red-brick structure, seen below with members leaving after Sunday morning worship service. In the 1970s, church pastor Rev. Ben Padgett was appointed, he thought, to relocate the church. The congregation soon learned that the early stipulations of the use of the property prevented it from being sold, relocated, or disposed of in any way, as set by Patton, or it would revert to the original owner or heirs. The church would stay put, and goals were set to revitalize it; also, a new name was chosen. Patton Chapel Methodist Church became Valley United Methodist Church. (Both courtesy of Hoover First United Methodist Church.)

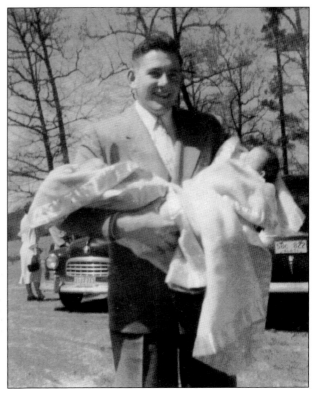

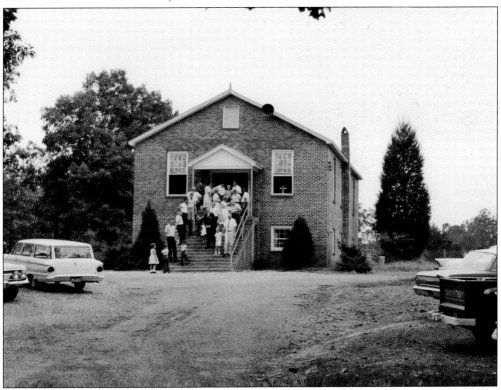

PATTON CHAPEL KIDS. Pictured here among others on a sunny day in 1980, Sara Barber, Michelle Marston, and Keith King prepare for a hike. Kids and young adults at the church had many activities to participate in, such as camping, sports, games, and choir. (Courtesy of Hoover First United Methodist Church.)

FRIEND TO THE CHILDREN. Torrencie Bailey (1918–2014) was one of the most loved and active members in the church, even into her 90s. It is often said that she raised more children in the church "than we [congregation] could count." August 8, 1992, was deemed "Torrencie Bailey Day," and pictured here accepting her award of appreciation is Torrencie Bailey. (Courtesy of Hoover First United Methodist Church.)

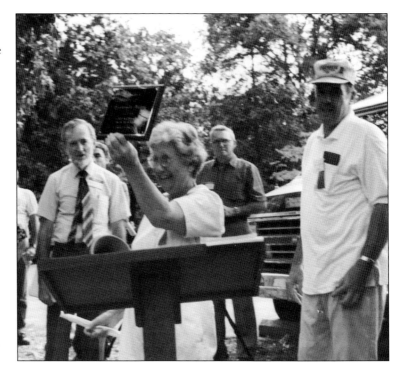

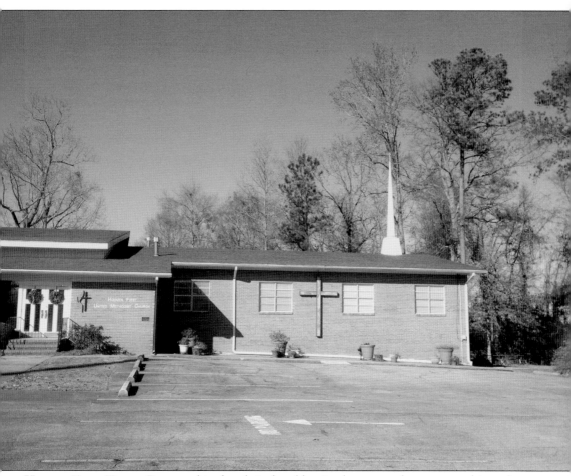

HOOVER FIRST TODAY. Because this church is the oldest in the area and was annexed into the city of Hoover, a resolution was set in 1994 that the name be changed to Hoover First United Methodist Church no later than January of the new year. Church historian Mary Graves writes in *The History of Hoover First United Methodist Church*, "The hardships of Patton Chapel/Valley/ Hoover First's first members have made a deep, lasting impression on those living today. Great Souls who were determined that this place of worship must never die have definitely been proven. The Church stands to prove that love, faith, endurance, determination and hope can keep a church vital through the changes of time." Today, after the widening of Patton Chapel Road, the wonderful green glass cross has been moved to the side of the church wall where its ethereal glow can be appreciated. (Courtesy of Hoover First United Methodist Church.)

GREEN VALLEY BAPTIST CHURCH. In 1962, there were only two main Baptist congregations in the small area soon to be Hoover. Ray and Lynn Faulkenberry had recently moved to the area and noticed a need for more Baptist congregations in the neighborhood. Philadelphia Baptist Church agreed to sponsor a mission in the area. In May 1962, the Hoover Baptist mission held its first services with Brother Tommy Briggs preaching. Brother Wayne Crumpton, who was serving as interim pastor of Philadelphia Baptist Church, began preaching at the new mission. Charter members were Mr. and Mrs. Wayne Crumpton, Mr. and Mrs. Ray Faulkenberry, Mr. and Mrs. W.H. Ainsworth, Mr. and Mrs. John Patterson, Mr. and Mrs. Robert H. Walker, and Mr. and Mrs. Jim Childers. (Author's collection.)

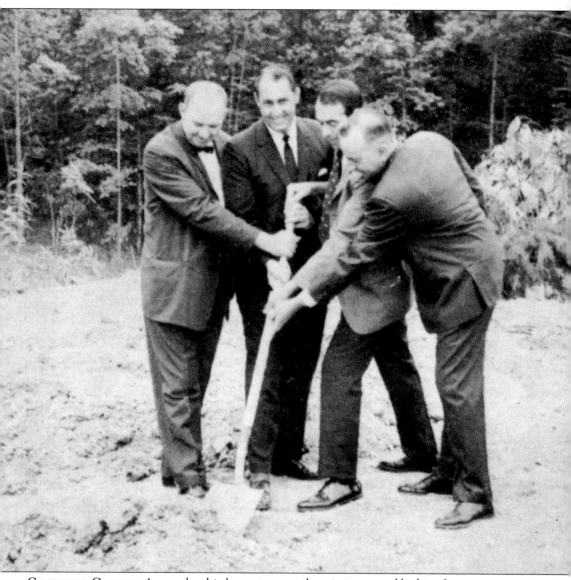

CONTINUED GROWTH. As membership began to grow, the mission started looking for a permanent home and found a 10-acre lot on Patton Chapel Road owned by Jim Warren. Philadelphia Baptist Church purchased the property, and architects were hired. Ground breaking for Green Valley Baptists Mission's first building was on November 3, 1963, and the following April the building was finished. Lakeside Baptist Church presented a gift to the new church to purchase new chairs. In September 1965, Green Valley Baptist Mission became Green Valley Baptist Church. The year 1966 brought Green Valley a new chapel. The ground breaking for the church's new chapel was held on April 17. New buildings were added in 1967 and 1968, including an educational building. Pictured here from left to right are Oley Kidd, associational missionary; Roy Barron, building committee chairman; Wayne Crumpton, pastor; and A.R. Smith, architect, breaking ground for the new education building that is the third in a series of eight buildings on campus. (Courtesy of *The Alabama Baptist*.)

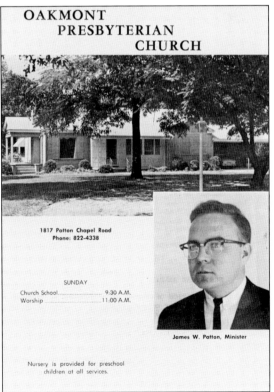

OAKMONT PRESBYTERIAN CHURCH

1817 Patton Chapel Road
Phone: 822-4338

SUNDAY
Church School................9:30 A.M.
Worship.....................11:00 A.M.

James W. Patton, Minister

Nursery is provided for preschool children at all services.

OAKMONT PRESBYTERIAN. The Presbytery of Birmingham saw a need for an additional church in the area, and Rev. William Hood acquired 10 acres in 1964. The first services were held in a farmhouse, and later that year Rev. James "Bill" Patton (1964–1977) became organizing pastor. By 1965, Oakmont Presbyterian was chartered as a church with 53 charter members. Pictured at left is a bulletin from the 1960s showing the little house and Reverend Patton. The familiar A-frame fellowship hall was completed in 1967. Rev. John Larson became pastor of Oakmont in 1978, and by 1983 the church converted the fellowship hall into a sanctuary and added more facilities. Oakmont will celebrate its 50th Anniversary in 2015. Rev. Richard Brooks has served the church as pastor since 2008. (Both courtesy of Oakmont Presbyterian-Ralls Coston.)

First Baptist Church of Hoover. The Patton Chapel Mission began in 1952. Howard College student LeRoy Anthony became pastor while meeting at the home of Ben and Ocie Weems. The Weems gave land for the first church building. In 1954, it was renamed Patton Chapel Baptist Church. There were 17 charter members: Leroy Anthony, Claudia Everett, Fal Everett, Lona Greer, Mary Greer, Helen McClendon, J.E. and Mrs. Parker, Fleda Russell, Minnie Russell, William Russell, Lester Russell, Nora Sexton, William J. Sexton, Douglas Spain, and the Weems. Between 1964 and 1974, under Mack McCollum, the church congregation multiplied. McCollum was followed by Steve Minor, the church's first full-time pastor. (Courtesy of First Baptist Church of Hoover.)

St. Peter's Catholic Church. The first Catholic Church of record in Hoover began on June 15, 1962, and was established by Archbishop T.J. Toolen. Msgr. Edwin Bobe was appointed the first pastor of St. Peter's Catholic Church. Bobe was later joined by Fr. John Robinson. A small farmhouse, once owned by the Dudley family, served as the parish's first rectory. James Adams, a local architect, along with Thornton Construction Company, built the first church on the property. Pictured above in September 1962 is the church being built, and the finished church is seen below. The first Mass was celebrated on December 16, 1962, with seating for 300 people. (Both courtesy of St. Peter's Catholic Church.)

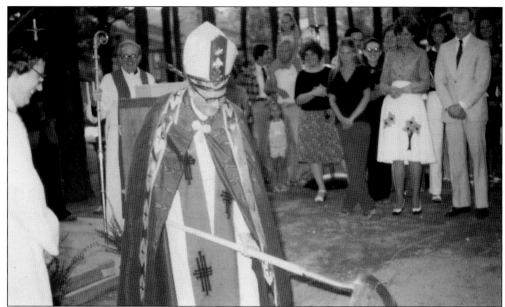

GROUND BREAKING AND GROWTH. Bishop Vath, pictured above, breaks ground by turning the first shovel of dirt. Seen below is Msgr. Francis Wade, pastor of St. Peter's, as he takes his turn breaking ground for the new church. The ceremony was also attended by members of the church, both adults and children, seen in the background watching the ceremony. In 1970, the church was expanded. A new church building was developed in 1980 with Monsignor Wade and was dedicated on August 9, 1981. The original church building is now used as the parish's office. Today, the new sanctuary seats approximately 1,000 people, and the church has a membership of over 1,500 families. (Both courtesy of St. Peter's Catholic Church.)

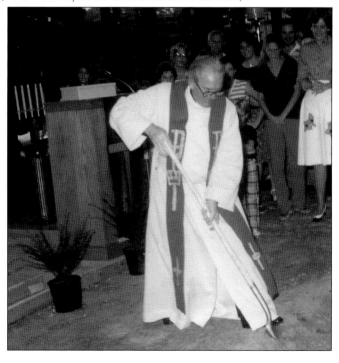

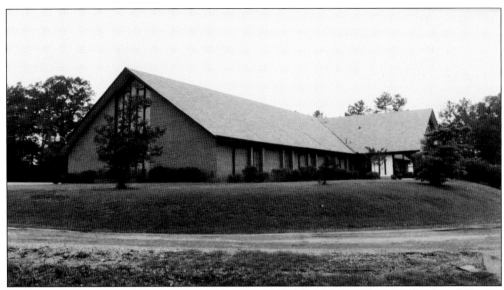

HOOVER CHURCH OF CHRIST. In 1963, a meeting was held at Patton Chapel School, and Hoover Church of Christ was founded with 27 charter members. William Henry Hoover, who owned Patton Chapel School's property, agreed to its use as a meeting place. The first worship service was held on August 4, 1963. The name was chosen to reflect the feeling that, someday, there would be a city of Hoover. In 1963, the congregation negotiated and bought the property from William Henry Hoover. In 1966, a new building (above) was constructed, and the congregation moved out of the old school building. Jack Coker assumed preaching duties that year, and the first elders appointed were Bob Black and Harland White. Arnold Sexton was the first full-time minister. The church still stands at its original location. (Both courtesy of Hoover Church of Christ.)

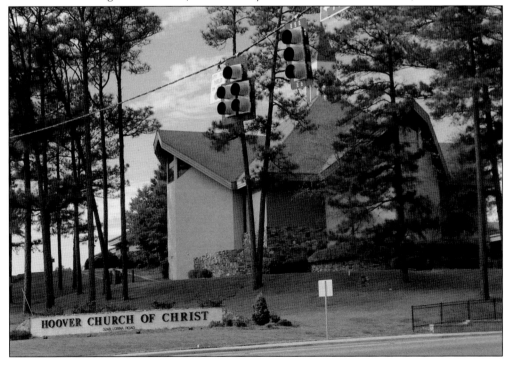

A People, Not a Building. Hunter Street Baptist dates back to 1907 and moved to Hoover from Fourth Court West in the late 1980s. At that time, the average age of the members was 69, and there were no children or youths. Buddy Gray had been the pastor for one year. The church was faced with three options: close, move, or sell. In 1987, the 220 members voted to sell the Fourth Court West building. These faithful members trusted God with their future and believed it was God's plan for them to move across the city to 11 acres of land on Highway 150 in Hoover. The new Worship Center (now the Chapel) was dedicated on Easter Sunday in 1989. Pictured below from left to right are Dwight Satterwhite, Pastor Buddy Gray, and Richard Smith. (Both courtesy of Hunter Street Baptist Church.)

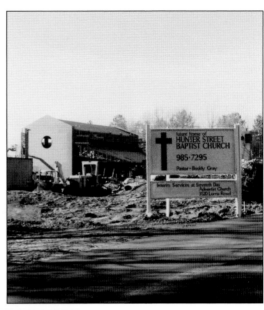

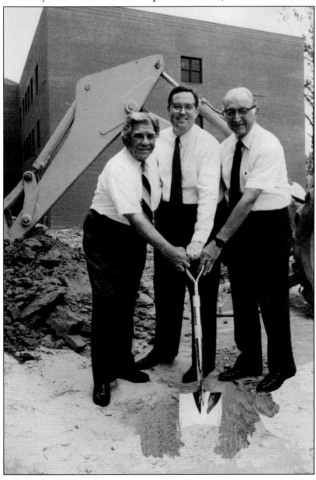

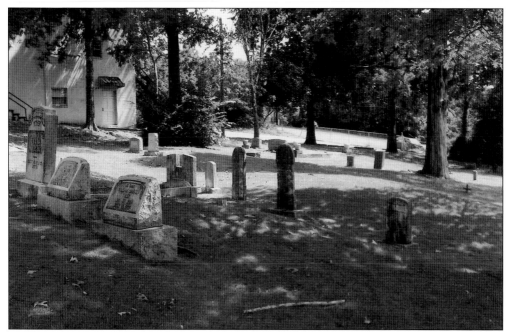

BLUFF PARK CEMETERY. In Bluff Park, the founding families and those pioneers of the resort community rest in a small cemetery first used by Summit Baptist/Bluff Park Baptist Church. In 2003, Bluff Park Cemetery was listed on the Alabama Historic Cemetery Register. (Author's collection.)

PATTON CHAPEL CEMETERY. Newly listed on the Alabama Historic Cemetery Register is this place of rest on Patton Chapel. The early founders of the Patton Chapel community are buried here, including Samuel Patton Sr. (1833–1909), Sarah L. Patton (1836–1918), and the Taff family, along with Everett Earl Taff Sr. (1927–2005). The first grave in the historical cemetery is that of a unknown child. (Author's collection.)

Three

EARLY SCHOOLS

EDUCATIONAL GROWTH

ROCKY RIDGE SCHOOL. Rocky Ridge formed from a church of the same name. The Presbyterian Church deeded land in 1881 to build a school, and it was called Rocky Ridge School. The first teacher was Prof. E.C. Watkins, who educated the children along with his daughter Mary Watkins. The Hoover Historical Society placed a historical marker at the site in 2005 as Hoover's first school. (Author's collection.)

EDUCATION IN ROCKY RIDGE. School began with a few classes meeting a few times a month at Rocky Ridge Cumberland Presbyterian Church in the 1850s. In 1881, land was deeded for a log building, and in 1889 a frame building was started that was completed in 1893. In 1927, a three-room school replaced the building. This hand-drawn image of the school in 1927 resides in a scrapbook compiled by the Rocky Ridge PTA in 1953. In this schoolhouse, there were two teachers and eight grade levels. In 1931, Pleasant Valley Elementary was consolidated with Rocky Ridge, which gave the school three teachers for the eight grades. Seven years later, the school went back to two teachers but with six grades. The location has varied by only a few yards since its inception. The first principals were E.C. Watkins, Sara Pritchett, Mary Watkins, and Sara Manning. Electric lights and running water were soon added, and coal stoves were used for heat until 1946, when a furnace was installed. (Courtesy of Rocky Ridge Elementary School.)

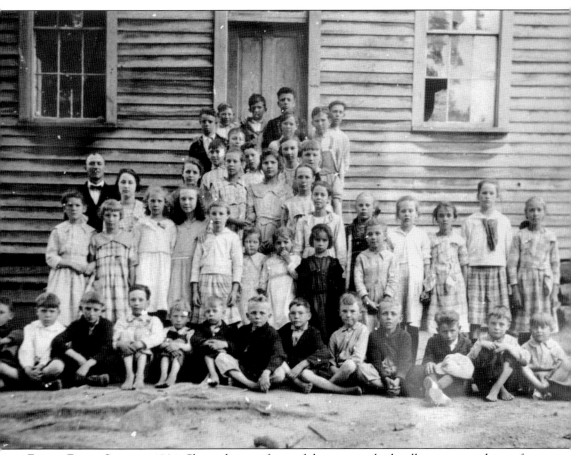

ROCKY RIDGE SCHOOL, 1921. Shown here in front of their original schoolhouse are students of Rocky Ridge School. From left to right are (first row) Carlos Duke, Johnny Bailey, Austin Sweet, Wilson Caldwell, Roy Roberts, Harold White, Lloyd Caldwell, Stephen Bailey, Wayne Acton, Floyd Caldwell, Havron Carpenter, Cecil Vanderford, and Harold Bailey; (second row) Pauline Bailey, Julia Watkins, Louise White, Goldie Roberts, Florene Bailey, Lois Caldwell, Mildred Carpenter, Helen Sweet, Annie Bailey, Estelle Acton, Lucile Bailey, Ida Action, and Willie Bailey; (third row) Prof. E.C. Watkins, Mary Watkins, Vella Mae Denman, Alma Caldwell, and Bertha Bailey; (fourth row) T.P. "Buster" Jones, Earl Carpenter, Lillie Lutchke, Allene Bailey, and C.D. Sweet; (fifth row) Brad Watkins, Fred Brown, Arthur Brown, Perry Vernon, Jim Morrison, Frank Brown, and Clarence Carpenter. (Courtesy of Rocky Ridge Cumberland Presbyterian Church.)

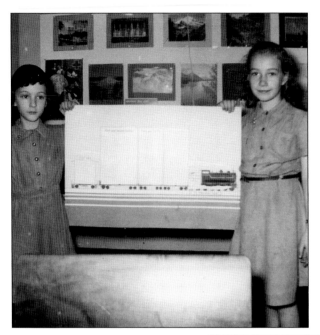

ROCKY RIDGE PTA. If it were not for the hours spent hand drawing and filling scrapbooks with early photographs, the history of Rocky Ridge would not be preserved today. The earliest scrapbook from the PTA dates back to 1953–1954. Each page is filled with freehand illustrations, news clippings, and photographs members of the PTA took. Pictured at left are Margaret Siddle (left) and Donna Gothard displaying a poster. Throughout the years, Rocky Ridge has always had a PTA. It started out small, but service to the school and community the members loved led to the betterment of students and staff. (Both courtesy of Rocky Ridge Elementary School.)

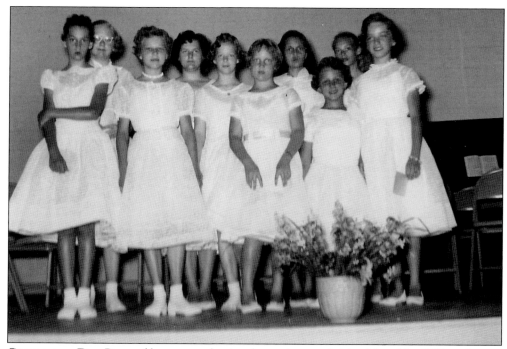

GRADUATION DAY. Pictured here on graduation day are boys and girls of the of the 1956 graduation class of Rocky Ridge School. That year marked the largest graduating class with a total of 24. One of the highlights of the year was a trip the class took to the state capital in Montgomery. A banquet was also held in its honor. Graduating were Hicks Arnold Jr., Sammy Bailey, Jimmy Campbell, David Coutta, Charles Coshatt, Franklin Garrison, Billy Hicks, Roger Howard, Gene Jones, Rodman Martin, Phillip Mattingly, Wallace Montgomery, David Rothoff, Ronny White, Cecilia Cantrell, Lonett Hodges, Charlotte Holle, Barbara Hughes, Dorothy Keller, Patricia Talley, Sheryl Threlkeld, Nancy Walker, Linda Waren, and Sandra Powell. (Courtesy of Rocky Ridge Elementary School.)

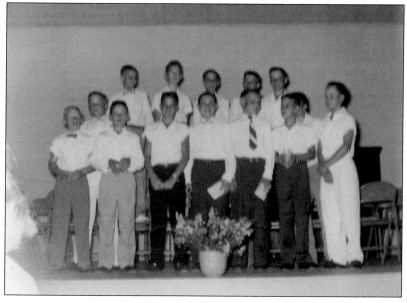

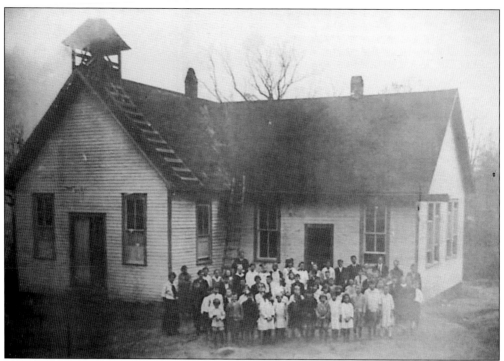

SUMMIT CHURCH AND SCHOOL, BLUFF PARK. In 1899, Summit Church and School was a one-room building standing at the intersection of Valley Street and Tyler Road. Pictured above in 1920 are schoolchildren at Summit. Notice the ladder going up to the schoolhouse bell on the roof. This school evolved into Bluff Park School around 1923 or 1924, when it moved to the current site on Park Avenue, pictured below. Since there were not many teachers to go around, Pearl Cranford and Ethel Hale taught the first classes at this location. In 1988, the school expanded from two classrooms to 32 classrooms, and in 1993 a new school was built next to it and opened in the fall. (Above, courtesy of Susan H.C. Kelley; below, Birmingham, Ala, Public Library Archives.)

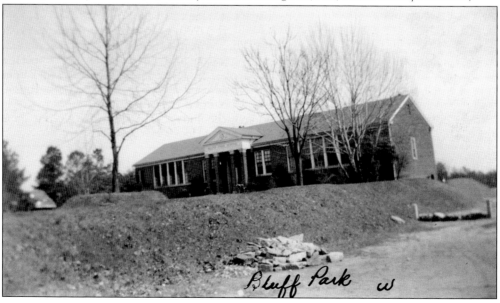

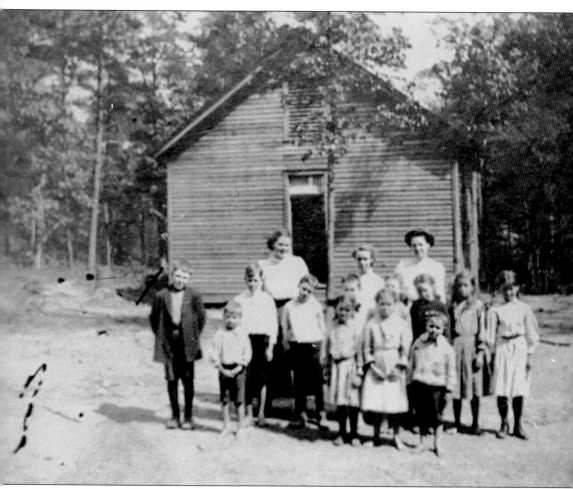

PATTON CHAPEL SCHOOL, 1909. Patton Chapel kids were first taught basic education around 1860 at the Patton Chapel Church or in homes. In the 1900s, a separate schoolhouse was built across from the church on Patton Chapel Road. The school remained in this location until 1922. In this photograph, schoolchildren stand with their teacher for a class photograph in front of the schoolhouse. The second location the school moved to was located at the intersection of Patton Chapel and (now) Lorna Roads. John Bailey and a group of carpenters, including John Patton, built the three-room schoolhouse. The Jefferson County Board of Education agreed to supply teachers if the community provided the land and schoolhouse. The school continued to grow and stayed in this location until the 1960s. (Courtesy of Hoover Historical Society.)

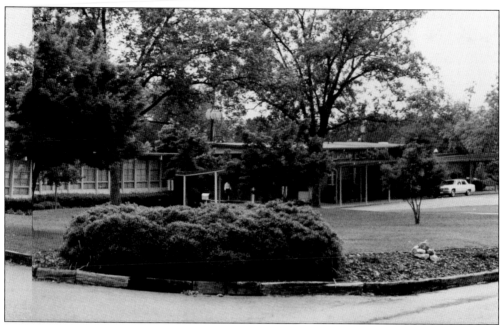

THIRD LOCATION OF GREEN VALLEY ELEMENTARY. Patton Chapel School moved one last time and reopened on Old Columbiana Road as Green Valley Elementary. The land for this school was given by William Henry Hoover Sr. Land was swapped with the Jefferson County Board of Education for the old Patton Chapel School location. The old Patton Chapel School building was used by Hoover Church of Christ and was also a private school before being taken down. Green Valley Elementary opened its doors in 1963 with only six rooms. The following year, an addition was built to accommodate growth, and in 1967 nine more classrooms and a library were added. In 1970, a new wing was built, and later a gym was constructed in 1972. (Above, courtesy of Hoover Historical Society; below, author's collection.)

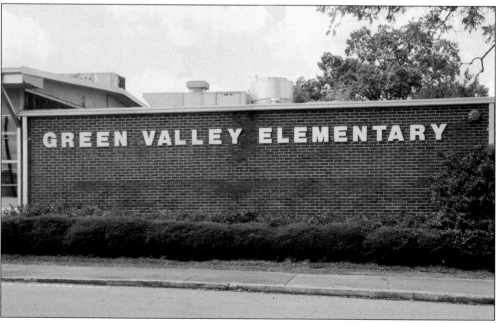

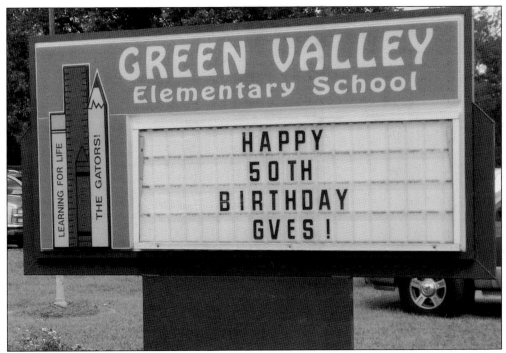

GREEN VALLEY ELEMENTARY, 50 YEARS LATER. More improvements to the building were made in the last 10 years. The school was reconfigured and upgraded. On Saturday, October 1, 2013, Green Valley Elementary celebrated its 50th anniversary with a festival that included games, inflatables, a silent auction, live music, and rides. Many former students and teachers returned to the school to celebrate. One wall displayed photographs from key points in Green Valley's life as a school. Today, Green Valley is one of the top schools in the Hoover City Schools system, serving over 400 students from kindergarten through fifth grade. (Both author's collection.)

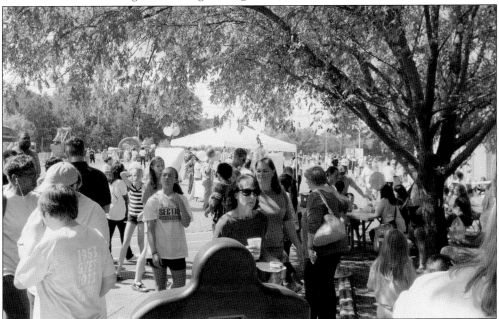

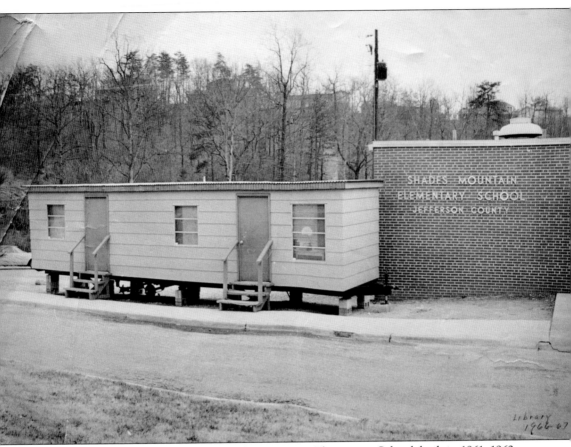

LIFE IS GOOD ON THE MOUNTAIN. Shades Mountain Elementary School, built in 1961–1962, was a county school until 1988, when the Hoover City Schools system was formed. Shades Mountain served children in grades first through fifth during its opening year. In 1963, more classrooms were added to accommodate moving the sixth grade from Berry in. The school library was kept in a temporary room until it could be staffed full-time with parent volunteers. What children would later refer to as "the blacktop" was an asphalt playground area with basketball goals. Between 1965 and 1968, sidewalks, a trailer for library use, and a new parking lot were added. Between 1970 and 1971, the seventh grade was added, and unfortunately the library caught fire, destroying all its materials. Here is a 1966 photograph of Shades Mountain Elementary School, and the trailer is where the library was located. After the fire, a library aide was hired, and materials were replaced. In 1973, special education classes were added, and by 1980 a gifted students teacher was hired. (Courtesy of Hoover Board of Education.)

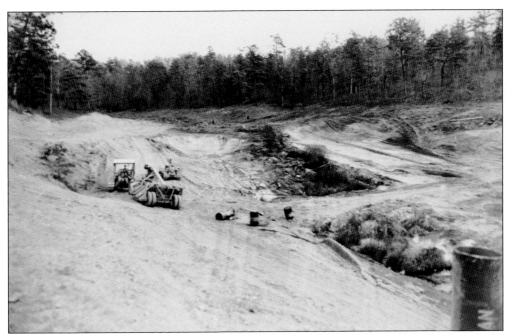

THE GROWING SCHOOL. Above is what Shades Mountain looked like before the school was built. The area was full of bedrock, and much work had to be done to prepare the ground before the first brick could be set. In later years, the school continued to grow with more students as the area grew. New playgrounds were added and also a gym. Pictured below are students and teachers working outside with members of the Hoover Beautification Board to plant a tree in the median in front of the school. (Above, courtesy Hoover Board of Education; below, Hoover Beautification Board, Hoover Historical Society.)

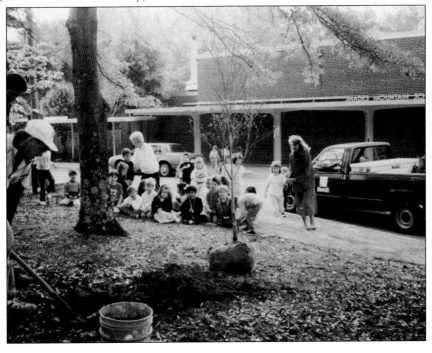

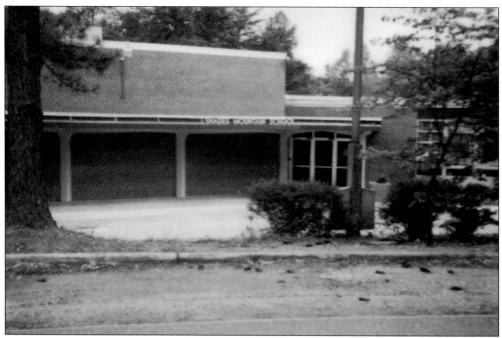

SHADES MOUNTAIN ELEMENTARY TODAY. Shades Mountain is among the top schools in the city of Hoover. The front of the school was refurbished and remodeled, as were the other Hoover city schools to give a uniform look. A community playground was added, which can be used by locals after school hours for playtime or birthday parties, along with a walking track. Sumpter Street was also widened, and sidewalks were added. The old wooden playground in the corner woods on Sumpter Street was not used for many years due to safety and was also taken down. The school's mascot has always been a lion, which is an acronym for "Learning In Our Neighborhood School," describing the character of Shades Mountain and its school. (Above, courtesy Mountain Oaks Garden Club, Hoover Historical Society; below, Christy Monczka.)

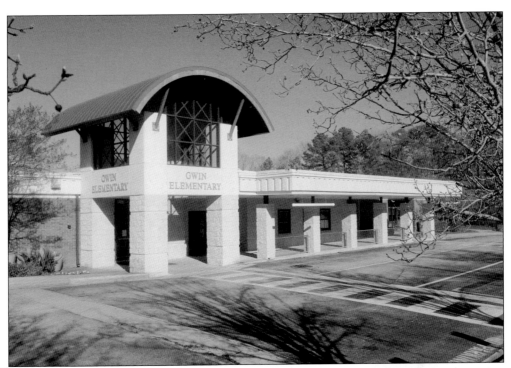

NEED FOR A NEW SCHOOL. As the city of Hoover grew, it became evident in the 1970s that there was a need for an additional elementary school in the mountain area. Because of the growing classroom size at Bluff Park and Green Valley, Gwin Elementary School was built and opened in 1976. In 1992, a new addition doubled the size of the school. This addition made room for more classrooms, a larger library, art and band rooms, and a science lab. The name *Gwin* was chosen for the new elementary school in honor of Harriette W. Gwin, a Jefferson County Board of Education member. (Above, author's collection; at right, Squire Gwin.)

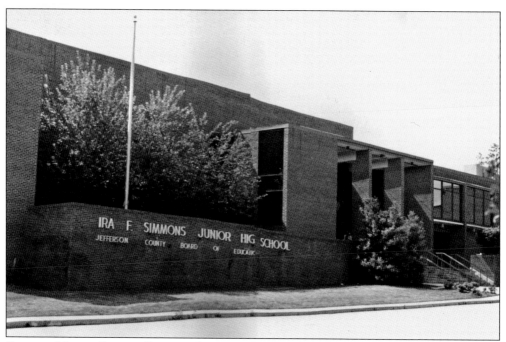

SIMMONS MIDDLE SCHOOL. Simmons Junior High School was built in 1979 to house seventh and eighth grades to relieve overcrowding at Berry High School. The school was named in honor of Ira Fitzgerald Simmons, a former superintendent of the Jefferson County School System. Bob Chapman was Simmons's first principal, and coach Wayne Wood was one of the charter teachers. In the late 1990s, sixth grades from each elementary school (except Green Valley Elementary) were moved to Simmons. The last renovations made to Simmons Middle School were in 1995–1996. Today, enrollment at Simmons is around 860 students. (Above, courtesy of Hoover Historical Society; below, Christy Monczka.)

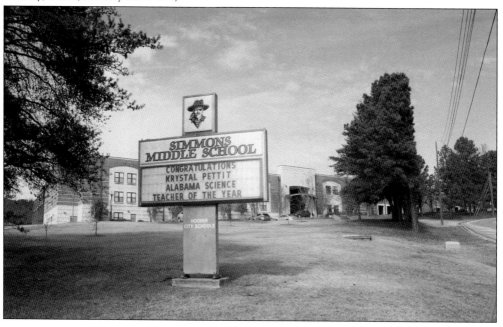

BERRY SCHOOL. There was much talk about a new school coming to Shades Mountain in the late 1950s, and it was much needed by the community. Berry School first served the Over the Mountain community as an elementary school (grades first through seventh) in 1959–1960 before Hoover was even a city or school system. The mountainous land had to be graded and prepped for the construction. The school was named for Col. William Andrew Berry, an educator and superintendent of Jefferson County Schools. The first principal was John Edwards, and Jacqueline Hall was the registrar. Berry's first coach was Larry Wilson. Berry continued as a high school, serving grades ninth through twelfth, until the closing after the opening of Hoover High School. (Both courtesy of Jacqueline Hall.)

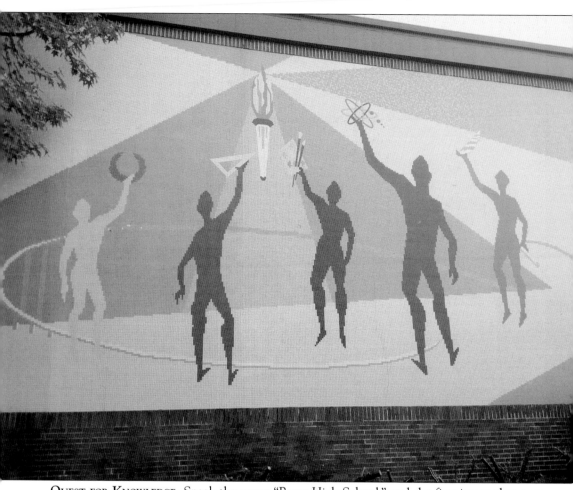

QUEST FOR KNOWLEDGE. Speak the name "Berry High School," and the first image that pops into one's head is this: a mural designed by student Kerry Buckley in the 1960s. Berry needed something to cover the blank wall of a new classroom building that faces Columbiana Road. Art students at the school submitted drawings for the mural, and Buckley's drawing was selected. The mural on the 20-foot-by-42-foot wall illustrates the five fields of education. The wreath symbolizes athletics, the triangle stands for math, the paintbrush and palette depict the arts, a test tube and atomic symbol represent science, and lastly, the quill and scroll stand for humanities. Approaching its 50th anniversary, the mosaic mural is found to be in need of some restorative work. (Author's collection.)

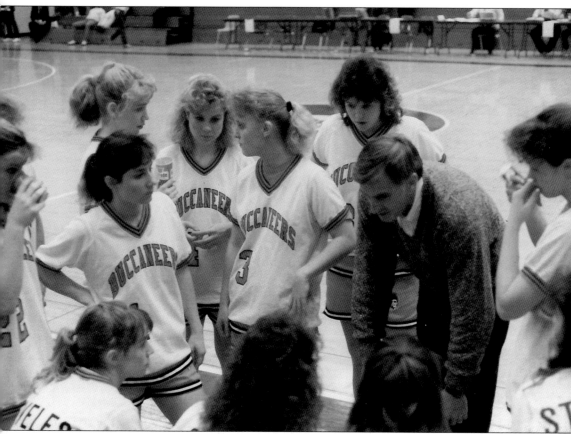

BERRY ATHLETICS. Coach Bob Finley started his 27-year coaching career at Berry High School as assistant coach in 1963. In 1968, Finley became head football coach and led the Berry Buccaneers to two state championships in 1977 and 1982. Finley also coached the ladies' basketball team, seen here. The girls made many playoff appearances and the final four eight times. Finley was inducted into the Alabama High School Athletic Association Hall of Fame in 1992. The Berry High School baseball team won more than 250 games and a state title under coach Gerald Gann. Gann also served as head football coach for four years at Hoover High School and coached in the Alabama-Mississippi All-Star Classic. In 2000, Gann was inducted into the Alabama High School Athletic Association Hall of Fame and the Alabama Baseball Coaches Hall of Fame in 2005. Gann coached 42 years in the high school ranks, including 16 years at Homewood High School. (Courtesy of Diane Finley.)

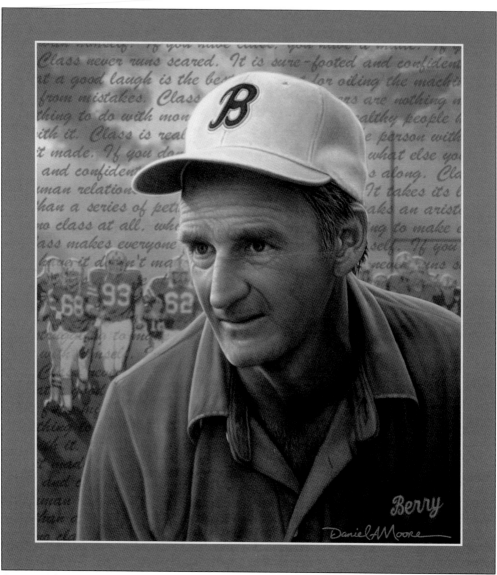

COACH. This portrait, titled simply *Coach* by noted sports artist Daniel A. Moore, immortalizes the Berry coach and was commissioned for the cover of a book on Bob Finley's life by Hoover coach Wayne Wood. The orange-clad Berry football players in the background to the left wear the numbers of Coach Finley's first (68) and last (93) football seasons. The player wearing no. 62 represents the artist's jersey number when he played for Berry but could also represent the first year there was a varsity football team. Above the players are proverbs on the subjects of poise and class that were the fundamental part of the coach's life and career. The proverbs were taken from an article titled "Class" by Ann Landers that the coach gave to his players. After Finley's passing, a scholarship was formed by a group of players to honor the coach, called the Robert O. Finley III Foundation. In 1996, the Finley Awards Banquet was established to honor select students and staff who share the same characteristics as the coach. (Courtesy of Daniel A. Moore.)

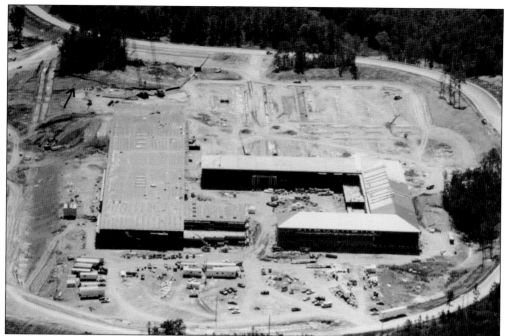

BERRY HIGH SCHOOL AND HOOVER HIGH SCHOOL. A new, larger high school was needed for the fast-growing city. The new school, Hoover High School, opened off Highway 150 for the 1994–1995 school year. The school was hit with the unexpected death of coach Bob Finley before the school year began. A black wreath was placed at the school by some of his players. Above is an aerial photograph of the school as it was being built. Another leader in Hoover education was Gene Godwin. Godwin served 29 years with the Hoover City Schools system, teaching at Green Valley Elementary and Simmons Middle School and serving as principal at Hoover High School. Godwin passed away in 2004, and a memorial scholarship was created in his name for high school seniors. (Above, courtesy of Hoover Board of Education; below, Christy Monczka.)

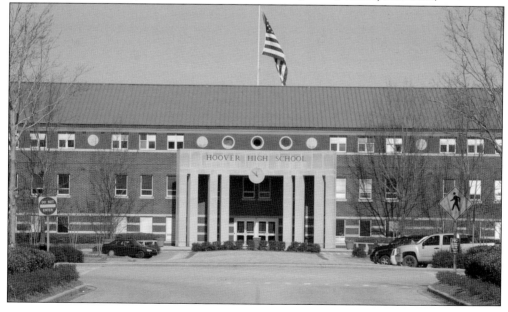

ATHLETICS MAKING CHAMPIONS. In 1999, coach Rush Propst, at left set the framework that would bring Hoover High School five Class 6A state championships with the first in 2000. In 2005 and 2006, the school and football team were the subjects of the MTV (Humidity Entertainment) reality show *Two-A-Days*, which lasted two seasons. Below, Hoover's current coach, Josh Niblett, took over the powerhouse football team after Propst resigned in 2007. Niblett coached the Bucs to championships in 2009 and again in 2012. Pictured below are Coach Niblett and the Hoover Bucs after winning the 2009 Championship. (At left, courtesy of the Jones family; below, David Parker, AHSFHS.org.)

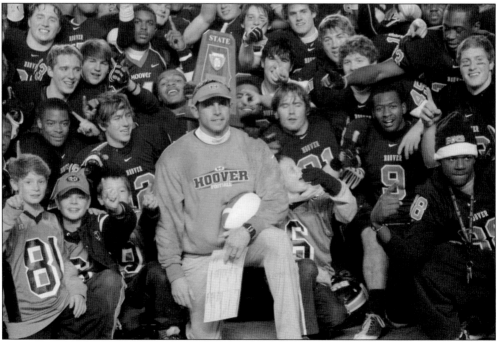

Four

EARLY HOOVER BUSINESSES
HIGHWAY 31 DEVELOPS

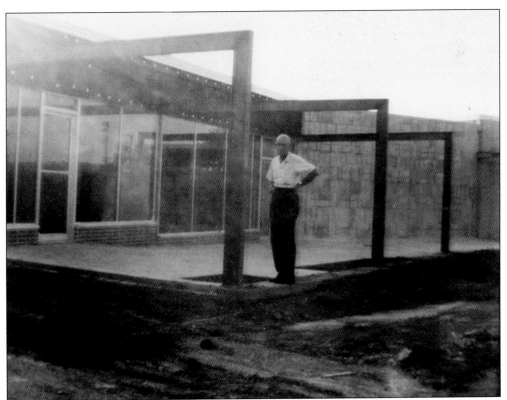

HOOVER COURT COMPLEX. Pictured here in September 1961 is Robert Carson Barnes checking out the construction site of Dr. James H. Gillespie Sr.'s new dental office. The building was located next to Green Valley Drugs in the complex known as Hoover Court. Papa Joe's Pizza was another popular business in this complex, which is the original site of Employers Insurance, William H. Hoover's company. (Courtesy of Linda Cato Wurstner.)

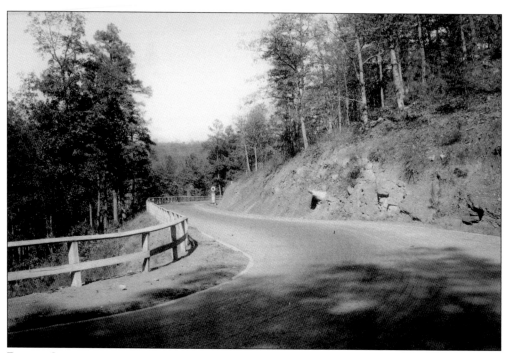

Blank Canvas. Here are two illustrations of what US Highway 31 looked like before the development of early Hoover or what other surrounding cities and municipalities would have looked like. The postcard below sets the scene of an old winding road with just a white fence railing among the autumn leaves. The early photograph above shows the road with a single gas pump in the distance. What a difference time has had on this heavily traveled road! Both images are among a collection preserved by the Birmingham Public Library at the Linn Henley Research Library. (Courtesy of Birmingham, Ala, Public Library Archives.)

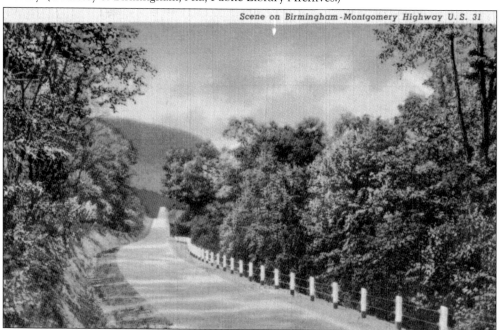

Scene on Birmingham-Montgomery Highway U.S. 31

THE MOVE TO THE BOONDOCKS. Employers Mutual in Birmingham became successful and steadily grew after the Depression. In 1929, the company converted to a stock company, and in 1944 Employers Life Insurance Company formed. In the 1950s, William Hoover started buying up property on Highway 31 south of Vestavia. He saw this as a good investment and realized the growth of Birmingham moving southward was coming. The first building to go up was Employers Insurance Company of Alabama. Hoover was moving his company from Birmingham to the "middle of nowhere." The ground breaking was December 1957, and the building was finished in 1958. (At right, courtesy of Hoover Public Library, Hoover, Alabama; below, Jane Hoover Parrish.)

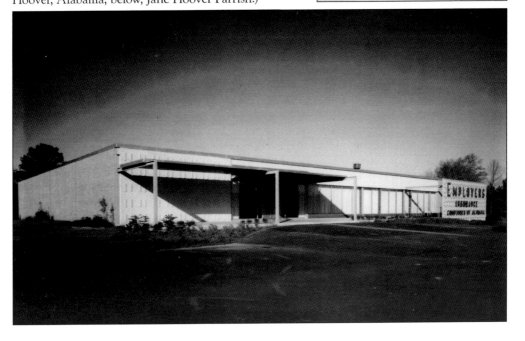

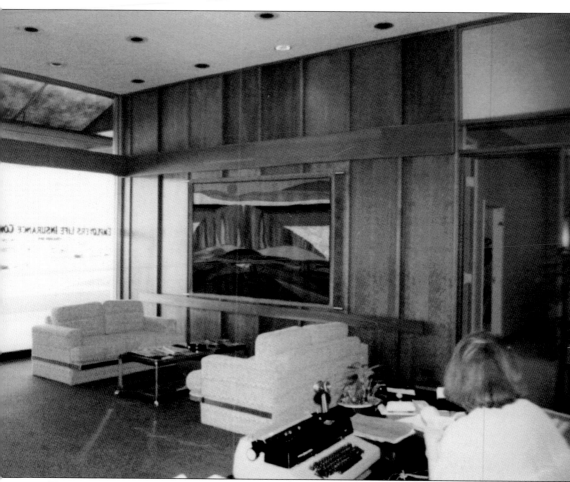

EMPLOYERS LOBBY. This is the lobby of the Employers Insurance Company of Alabama. In the early years, beginning with this building, the rest of the city's businesses began to establish and grow. Roberts and Son, one of Birmingham's oldest businesses, followed and was the second to move to the Hoover area. Today, this complex is still full of stores, and the original flagpole is still there. (Courtesy of Hoover Family Scrapbook, Hoover Historical Society.)

HOOVER A&P, 1963. In 1962, Hoover announced the addition of several stores and complexes in the Hoover Court Shopping Center. The A&P supermarket was one of the stores announced, and its construction was completed that spring. It was one of the few places to get groceries in the city's early days. People recall employees carrying big brown paper sacks filled with groceries to patrons' cars. This was also a time before scanners, so cashiers would have to punch the price into a large manual register. William Henry Hoover Sr. is pictured below (right) in front of the Hoover A&P. (Both courtesy of Hoover Country Club.)

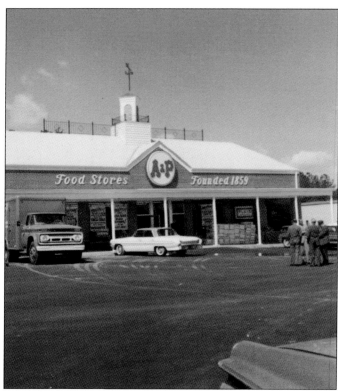

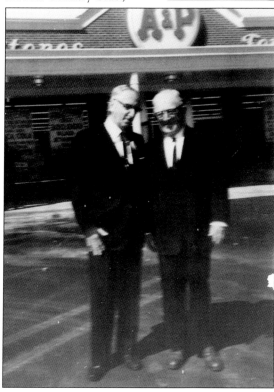

ONE OF THE OLDEST BUSINESSES. Joe Box, a local pharmacist and teacher, opened Green Valley Drugs in 1961. The store had the first computerized pharmacy system in Birmingham around the early 1980s and remains a staple in the history of Hoover. Along with its friendly service and personal attention to clients, one of the popular draws to the pharmacy is the old-fashioned soda fountain. The original booths are still there, and early menus show cheeseburgers costing 90¢ and milk shakes 50¢. The famous cheeseburgers are still served today, but they cost a little more. Green Valley Drugs has often been called the hub of Hoover from the early years. It was the gathering place for early Hoover city staff, including the mayor, council, and fire and police personnel. Green Valley Drugs celebrated it 50th anniversary in 2011. Torrencie Bailey (1918–2014) started working at Green Valley Drugs not long after it opened and served patrons into her 90s. Bailey, a cornerstone in the foundation of the store, passed away in July 2014. (Courtesy of Christy Monczka.)

MORE IN HOOVER COURT AND SURROUNDING AREA. Here are two advertisements from a Hoover Civic Club community directory. The Hoover Beauty Center, located in the Hoover Court Complex, was a great place to get a cut and a style. There was also a delicatessen, Bill's Five and Ten store, Utopia Cleaners, and J & J Hardware to name a few. The First National Bank of Birmingham opened its Green Valley branch in the 1960s and was the first bank in Hoover. The first location was at 1901 Hoover Court, and in 1967 the branch moved to the corner of Braddock Drive. Behind the complex, Hoover Court Condominiums was built in the Valgreen Lane area, which is also the site of the first parade of homes. (Both courtesy of Hoover Public Library, Hoover, Alabama.)

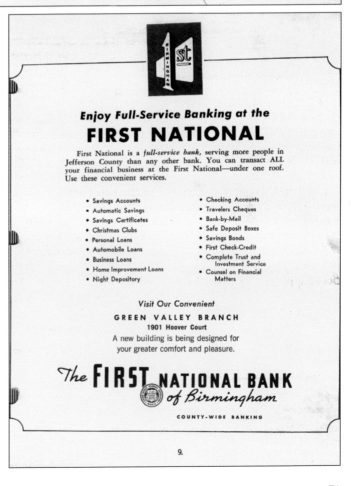

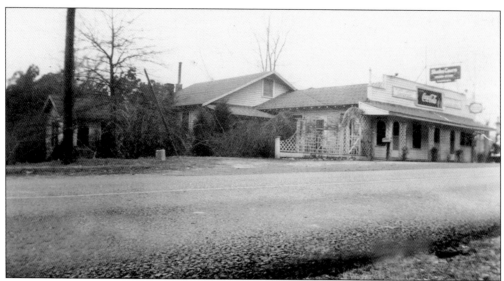

SHADES TAVERN. This property later had businesses such as Burger Chef (opened in 1967), El Palacio, Mr. Transmission, and Frame Factory in the general area. Board of equalization papers at the Birmingham archives list the owner of the property as D.E.G. Williams (or William). A handwritten note explains and protests a tax assessment dated May 14, 1943, on the property and that it went by Shades Tavern on Montgomery Highway (Highway 31). Records in 1953 indicate there were chicken houses also on the property. In a 1959 Birmingham South Quadrangle map, the Hoover Historical Society notes that the tavern was to the right of Lorna Road past the intersection of what is now Highway 31. Another of many taverns in the area was Friendly's Tavern, run by the Stewart family. (Both courtesy of Birmingham, Ala, Public Library Archives.)

DIXIE DAIRY KREME.
Once located on
Highway 31 in Hoover
near Green Valley
Elementary School
was the popular Dixie
Dairy Kreme eatery.
This advertisement from
one of the community
directories lists shakes
and malts and their
famous hamburgers
that cost less than a
dollar. (Courtesy of
Hoover Public Library,
Hoover, Alabama.)

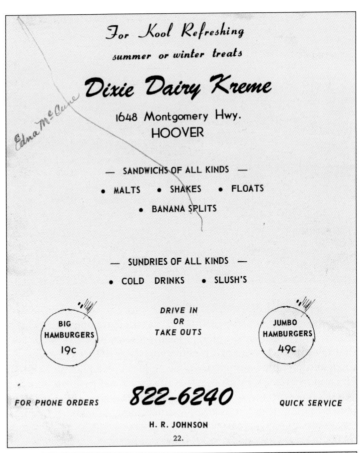

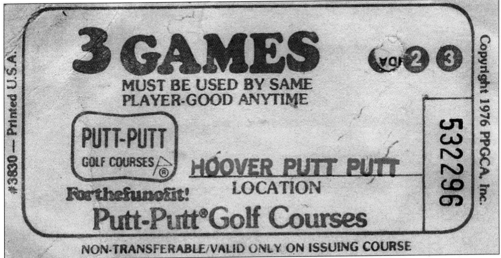

PUTT-PUTT GOLD AND GAMES. Johnny Jones and Joe Box opened a mini golf in 1976. Jones ran it, and in 1981 Box sold his portion to Jones (and two others). After adding an arcade, one machine thought broken was found to be stuffed full with quarters—the game was Pac-Man. Many birthday parties were held at Putt-Putt as well as game tournaments. Today, there is a Krispy Kreme where the iconic business once stood. (Courtesy of Putt-Putt, LLC, and ticket owner Richard Reid.)

SOUTH HAVEN NURSING HOME. South Haven Nursing Home was incorporated in 1962. The facility owned and operated by Fred and Rheta Skelton opened its doors in 1964 with 64 beds available, later growing to over 100. Pictured above is the building in August 1964 with many cars parked in front, and below is a wider shot of the facility with one of five additions and a sign. Today, the facility is still owned by the Skelton family and is leased to South Haven Heath and Rehabilitation, which offers 24-hour, seven-days-a-week, skilled nursing care. (Both courtesy of Birmingham, Ala, Public Library Archives.)

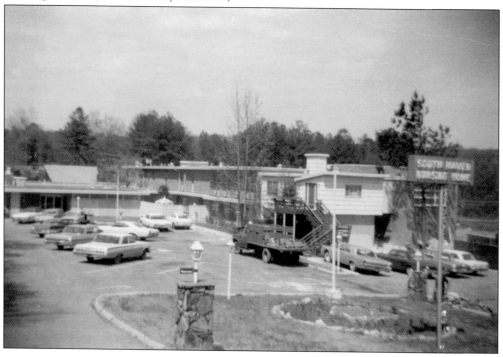

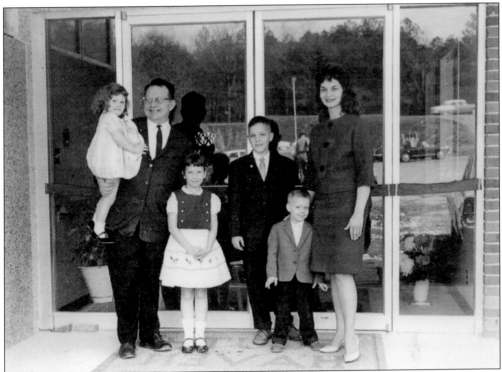

SOUTH HAVEN RIBBON CUTTING. Pictured here in March 1964 at the opening of South Haven Nursing Home are, from left to right, Loree J. Skelton, Fred T. Skelton Jr., Cynthia M. Skelton, Fred T. Skelton III, Brian L. Skelton, and Rheta S. Skelton. Brian is now a Hoover City councilman. (Courtesy of Brian Skelton.)

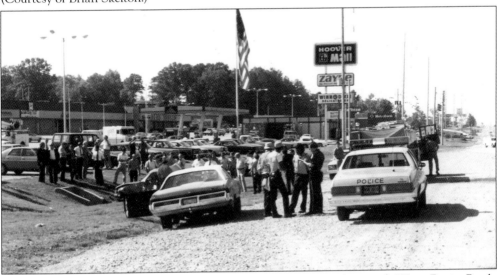

HOOVER MALL. The Hoover Mall opened in 1972 with Zayre, along with Winn-Dixie, Battle Buffet, Eckerd drugstore, and Brombergs. Following renovations, the mall became a strip mall. Burlington Coat Factory replaced Zayre and Books-A-Million opened (but closed in 2014). This unfortunate wreck shows the complex as it was before renovations, and the old logo is seen in the background. (Courtesy of the Hoover Police Department.)

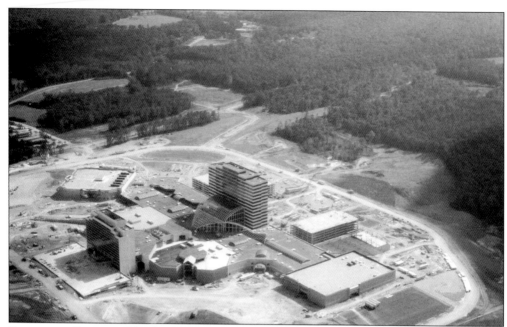

RIVERCHASE GALLERIA. This focal point in Hoover opened in February 1986 by developer Jim Wilson & Associates with four anchor stores: Parisian, Pizitz, Rich's, and J.C. Penney. The photograph above was taken in late 1985 as construction neared its end. In March 1987, Macy's joined by opening the company's first location in Alabama. In 1996, Sears and a new wing were added, making it the largest mixed-use enclosed shopping center in the Southeast. Riverchase Galleria complex also includes Galleria Tower and Hyatt Regency at the Wynfrey. During construction in the mid-1980s, part of the complex caught fire, making headlines in the news and setting back construction. The photograph below was taken from old city hall of the galleria fire in the distance. (Above, courtesy of Philip and Peggy Benefield; below, Hoover Police Department.)

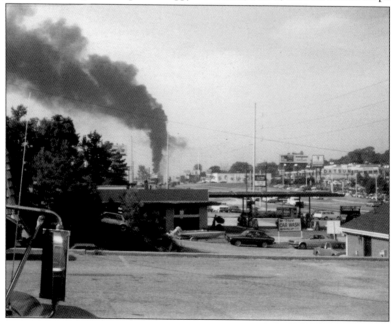

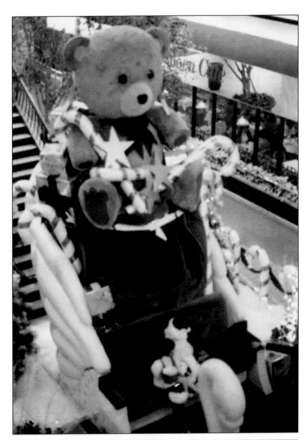

THE PLACE TO BE. Riverchase Galleria was the place to go and be seen in Hoover in its early years. It was customary to dress up in Sunday best for dinner in the food court, as shoppers would sit around the center fountain for dinner or dine at one of the restaurants inside. Another event was the annual photographs with Santa and the Christmas lighting. Pictured at right from the opening year is the large teddy bear display that Santa would sit on to take pictures with mall visitors, and below are the lighted reindeer that dance through the sky of the beautiful atrium. (Both courtesy of Bobbie Jane Gusnard.)

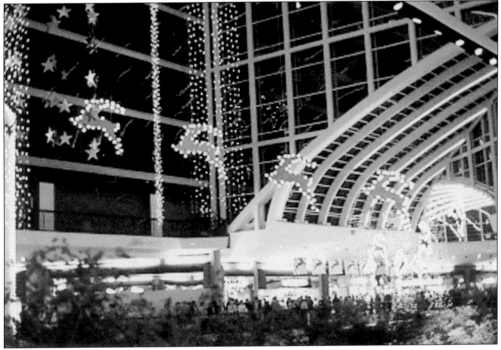

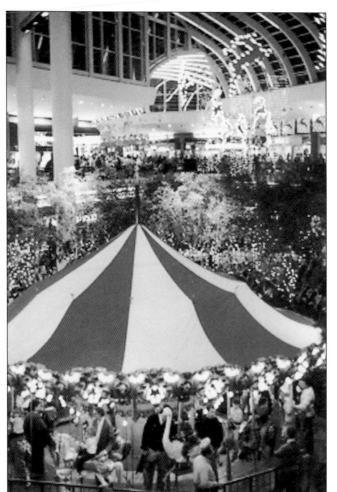

ORIGINAL CAROUSEL. Surrounded by the food court was both a fountain and carousel (seasonal) at one time. The 30-year-old carousel was taken down for a makeover in 2013, and its fabric top was replaced by lighted fabric streamers. The fountain is gone, and the carousel now sits level with the floor instead of on the support system that covered the fountain. (Courtesy of Bobbie Jane Gusnard.)

MOTEL AND INN. Built in 1965, this motel located across Highway 31 opened on January 1, 1966, as the Heritage House Motor Inn. The Southern Colonial–style main building had a restaurant, lobby, manager's apartment, and 40 rooms. The average rent per day in 1966 was $8. Ownership passed to several chains, including Ramada Inn and Days Inn. Today, the Heritage House is an Econo Lodge. (Courtesy of Christy Monczka.)

Five

EARLY CITY GOVERNMENT

RUNNING A GREAT CITY

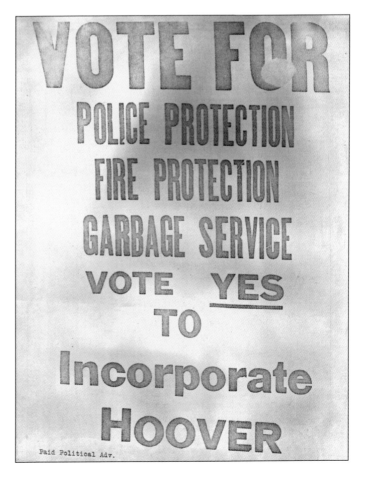

GOVERNMENT. After incorporation in 1967, the next step was a governing body. Jefferson County's 33rd municipality was born. Hoover's first mayor and city council served for one year with a four-year regular term vote to follow. These first officials had the monumental task of drawing up ordinances, finances, sanitation, police and fire departments, and zoning committees. They all had full-time jobs as well. (Courtesy of Hoover Family Scrapbook, Hoover Historical Society.)

FIRST OFFICIALS.
Don Watts (right), who was an active member of the Hoover Civic Club, became Hoover's first mayor. Watts was sworn in by Judge Paul Meeks, along with first council members O.E. Braddock, Edward Ernest, John Hodnett, Howard Rasco, and Dwight Roper. The council met the first and third Mondays of each month. Watts only served one term but is the city's first official mayor. (Courtesy of Hoover Historical Society.)

O.E. BRADDOCK. O.E. Braddock, vice president of Employers Insurance of Alabama, was first elected to the Hoover City Council in 1967 and reelected in the four-year regular term election the following year. Hoover's second mayor, Edward Ernest, resigned for personal and health reasons, and Braddock was appointed mayor in 1969. Braddock died suddenly while in office, and John Hodnett was appointed to finish the term. (Courtesy of Hoover Historical Society.)

LONGEST SERVING MAYOR AND HOOVER'S FIRST FEMALE MAYOR. Pictured above is Frank Skinner Jr., who was elected in 1980 and is the longest serving Hoover mayor on record, holding the office for 18 years. Skinner oversaw many developments in the young city, including the Hoover Public Library. Pictured at right is Councilwoman Barbara McCollum, who became Hoover's first female mayor in 2000 after a successful campaign and served a four-year term. (Above, courtesy of Hoover Public Library, Hoover, Alabama; at right, Jack Wright, Hoover City Council.)

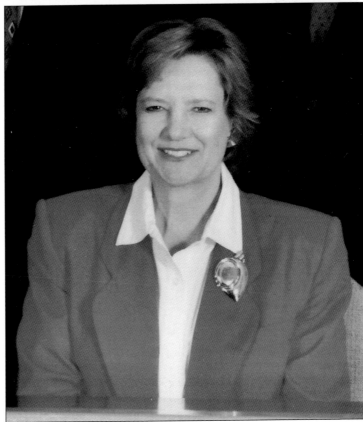

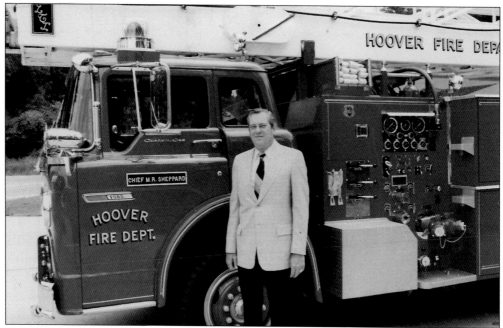

HOOVER'S FIRST FIRE DEPARTMENT. Pictured above in 1975 is Marshall Ralph Sheppard, who served as the first fire chief for the Hoover Volunteer Fire Department, from 1962 to 1976. Sheppard's son-in-law, Capt. W.P. Gresham, also served the Hoover community and retired from the Hoover Fire Department after serving from 1980 to 2007. The department was volunteer until 1970, when three people were hired. Wallace Peek, David Williams, and Tommy Thompson were the first employees. (Courtesy of Captain W.P. Gresham, Hoover Fire Department [Retired].)

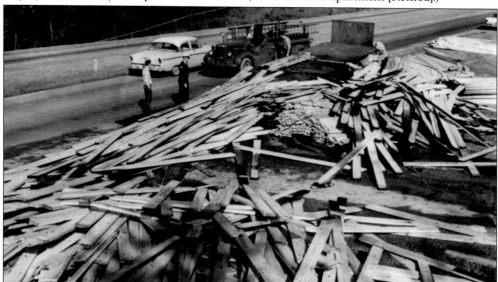

FIRST RESPONDERS. Here is one of the first emergency responses by the department, which was to an overturned trailer on US Highway 31 in 1963. At the site are Chief Marshall Ralph Sheppard, Hoover Volunteer Fire Department; Hartley Ayers, Vestavia Hills Fire Department; and O.E. Braddock and Raymond Patton, Hoover Volunteer Fire Department. (Courtesy of Captain W.P. Gresham, Hoover Fire Department [Retired].)

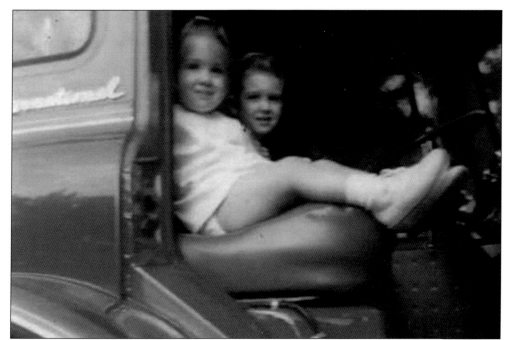

CHECKING OUT FIRST ENGINE. This is Roslyn Sahlman and Jack Simon, the daughter and son of Hoover resident Mae Simon, sitting for a photo op in the Hoover fire engine in 1967. Frank Skinner Sr. invited the kids to come see the new engine and have their photograph taken in this new addition to Hoover's fire-protection needs. (Courtesy of Mae Simon.)

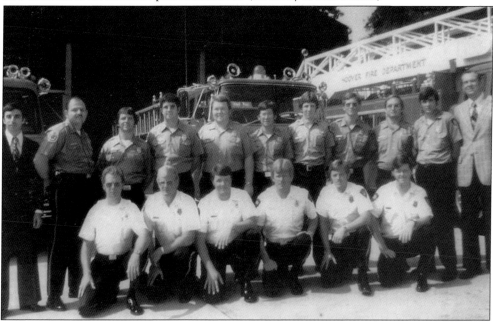

HOOVER FIRE DEPARTMENT. Seen in 1976 are members of the Hoover Fire Department (which was no longer a volunteer organization at this point). The fire engine was kept in an old garage behind Employers Insurance Company of Alabama, in front of the Hoover Fire Station No. 1. (Courtesy of Captain W.P. Gresham, Hoover Fire Department [Retired].)

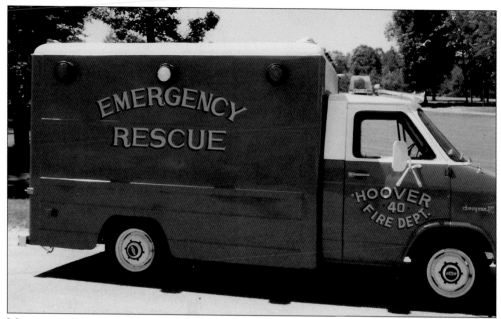

MEDIC AND RESCUE. The city of Vestavia Hills provided paramedic services to Hoover on a contract basis in the early years of the department. Later, emergency medical technicians were hired by Hoover to use "Rescue 40," seen here. This new unit dissolved the need for a contract with Vestavia Hills for service as Hoover now began to offer its own rescue service. (Courtesy of Hoover Historical Society.)

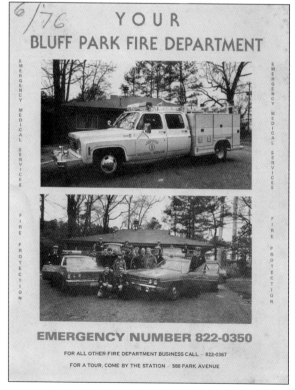

BLUFF PARK VOLUNTEER FIRE DEPARTMENT. The Bluff Park Fire District was well established when it was annexed into Hoover in 1985. At the time, it was the oldest fire district in the state. This home pamphlet from 1976 shows the truck and original fire department on Park Avenue in Bluff Park. Inside is a map of the district and other information. (Courtesy of Susan H.C. Kelley.)

HOOVER'S FIRST LAW ENFORCEMENT. James R. Norrell, a retired captain of detectives for the Birmingham Police Department, became Hoover's first police chief at the age of 65. The department began to grow, adding its first police car, a 1968 Ford Galaxy, and operating from an office in Hoover Fire Station No. 1. Norrell brought Oscar Davis on board to serve as a part-time patrol officer. When Norrell retired, the job of chief then went to Davis, who held the position for eight years. Pictured below are Chief Davis (far right) and Mayor O.E. Braddock (far left) with early members of the Hoover Police Department. Seen at right is the first Hoover Police Department patch, one of only a few that still exist. (Both courtesy of Hoover Police Department.)

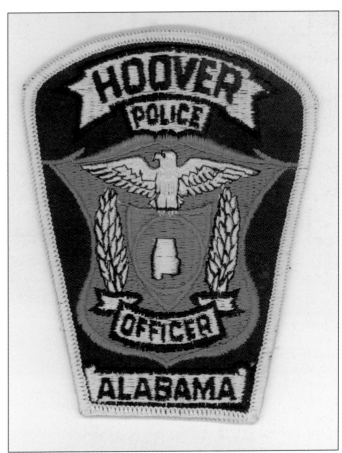

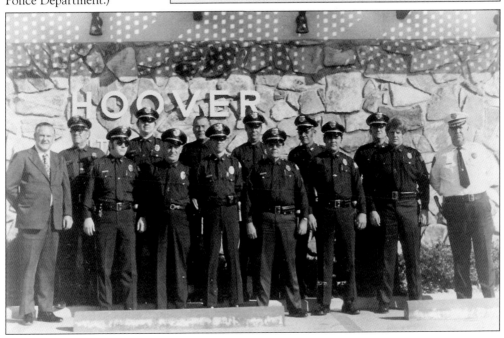

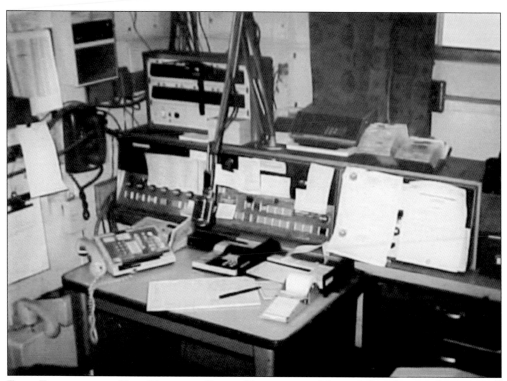

First Freestanding City Hall and Police Department. Hoover's first freestanding city hall opened in 1971 with space for police personnel and two jail cells. This was a big change. Above is the radio room where calls for service would come in to the Hoover Police Department. This photograph of city hall was taken by Oscar Davis in 1972. The original building is still standing today in its original location at 1631 Montgomery Highway. It is now a commercial endeavor and houses a cell phone company. (Above, courtesy of Hoover Police Department; below, Hoover anniversary scrapbook, Hoover Historical Society.)

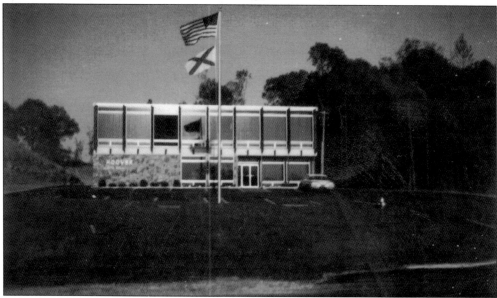

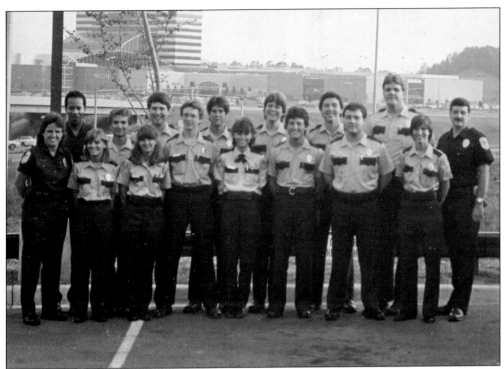

HOOVER EXPLORERS. In partnership with Boy Scouts of America, the Explorer Program provides young men and women the opportunity to study the field of law enforcement and community service first-hand. Each year, the Explorers contribute around 500 volunteer hours towards study and community service to the Hoover Police Department and the City of Hoover. Pictured here from the 1980s are the Hoover Explorers. (Courtesy of Hoover Police Department.)

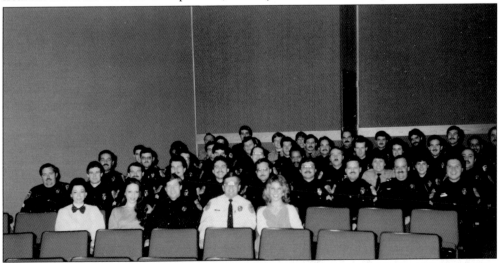

HOOVER POLICE DEPARTMENT GROWTH, 1980S. The department expanded in the 1970s and 1980s. David Cummings became chief in 1977, and the investigations division began in 1978. By 1986, there were 53 police officers. In 1988, the bomb squad formed. Then, in the 1990s, the tactical response team was created. The Hoover Public Safety Center opened in 2003 on Valleydale Road with a 72-bed jail. (Courtesy of Hoover Police Department.)

BEAUTIFYING HOOVER. Diane Deason, chairwoman for the Shades Mountain Junior Women's Club, is credited with bringing the idea of a beautification board to the Hoover City Council. By City Ordinance No. 229, the Hoover Beautification Board was established on October 17, 1977. Some of the first members appointed along with Deason were Lucile McClain and Jo Saye. Among its many projects, the board participates in the annual Dogwood Trail, garden tours, luncheons, and the annual Mayor's Prayer Breakfast. Board members also decorate the interior of the municipal complex for holidays by putting up trees, ribbons, and lights. Pictured below are Denise Roberson (left) and Sara Perry after decorating the council chambers for Christmas. (Both courtesy of Hoover Beautification Board.)

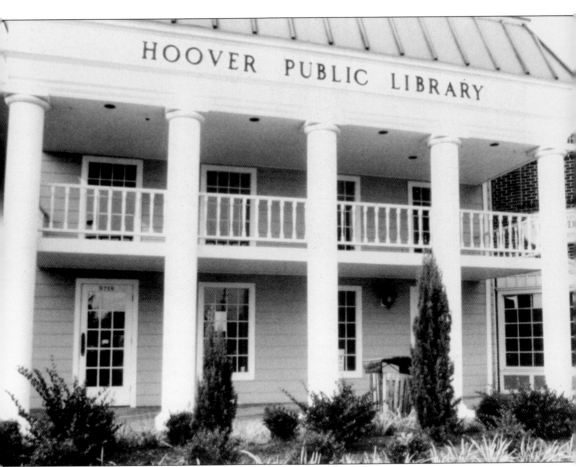

The Library Beginnings. As Hoover grew, residents needed a city library. A small group met in the home of Paul and Mary Lou Allen to discuss the possibilities. The group, which became the Friends of the Hoover Library, began circulating petitions, collecting thousands of signatures. In December 1982, the city council appropriated $100,000 for a new library. Mayor Frank Skinner appointed the first board of trustees, including Paul Allen, Philip Benefield, George Farmer, Eloise Martens, and Harold Shepherd. In April 1983, a lease was signed at River Oaks Village, and Linda Andrews became director of the Hoover Public Library. Pictured here is the first Hoover Library location at the River Oaks Village located on Lorna Road. The task of building the library collection fell to Andrews and her team of three full-time and five part-time employees. Around 8,000-plus materials were purchased for the library grand opening. It opened for business on October 8, 1983. Mayor Frank Skinner performed the ribbon cutting. (Courtesy of the Hoover Public Library, Hoover, Alabama.)

How to Move a Library. The photograph above from inside the first library location shows the large double windows allowing natural light to fill the space. The library remained at this location until 1985, as it was outgrowing its building. The original 8,000-volume collection had grown to more than 40,000. On November 4, 1985, the library closed its first location and prepared to move. In the weeks that followed, around 25,000 books were moved by the staff. Many books were also moved by the public. Staff and volunteers placed "A Library on the Move" label with instructions to return the books to the new location on 2,000 grocery bags used to sack library books that were being checked out during the two-week period before the close and move. (Both courtesy of the Hoover Public Library, Hoover, Alabama.)

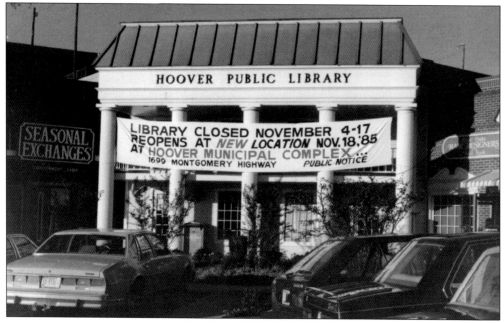

IN-BETWEEN YEARS OF THE HOOVER PUBLIC LIBRARY. On November 24, 1985, the library opened in its second location on the second floor of the Hoover Municipal Complex. This became the library's home for the next eight years. The space was double the size and had plenty of room for the growing collection. Shown here at the grand opening outside the new municipal complex are, from left to right, Philip Benefield, Mary Lou Allen, Eloise Martens, and Harold Shepherd. (Courtesy of the Hoover Public Library, Hoover, Alabama.)

HALLOWEEN AT THE HOOVER PUBLIC LIBRARY. With more room, the library was able to have more programs and guests. Halloween has always been a popular event at the library. Trick-or-treaters must beware of the "Circulation Desk Shark," also known as Pat Farr Ryan, pictured here in 1987. The shark often made its way around the library on Halloween (Both, courtesy of Hoover Public Library, Hoover, Alabama.)

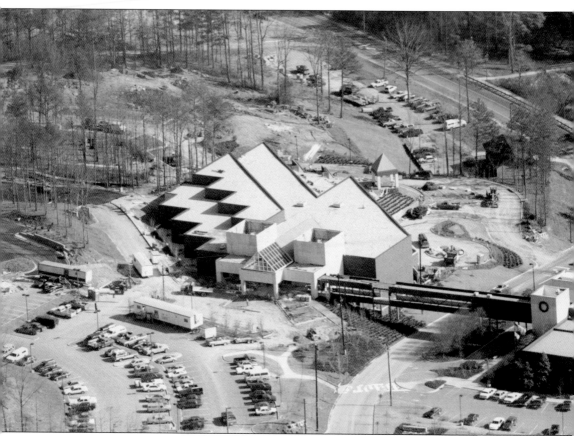

LIBRARY ON THE MOVE—AGAIN. As it continued to grow, patrons were going to see their beloved library move again; this time, just across the street. In 1987, Evan M. Terry Associates completed plans for a $5 million permanent library home. It would be three years later before the ground breaking of the permanent library location across from the city municipal center would take place. The holdup was due to budgets. Ground breaking finally began in early 1991, and in February 1992 the doors opened to the ultimate dream of the group that started in the home of Paul and Mary Lou Allen. Hoover had a new permanent, state-of-the-art library facility, and it is currently at this location. This aerial view is of the Hoover Public Library, located at 200 Municipal Drive. (Courtesy of the Hoover Public Library, Hoover, Alabama.)

HOOVER BELLES. In 1980, Faye Anderson created the Hoover Belles to serve as hostesses for the city. Each young lady had to be of exemplary character and reputation. As their advisor, Anderson held the girls to a strict code of conduct to represent the city. Anderson was also a friend and mentor to many belles throughout her years as their advisor. Belles apply and are chosen by current-serving belles. When choosing new belles, the girls are often asked, "Would you switch reputations with the girl you are nominating?" This was a good measuring stick. These two photographs show Hoover Belles at the Hoover Mall in 1980. The first 11 Hoover Belles were Jayna Sullivan, Michelle Hamilton, Karin Summerlin, Kathy Trowbridge, Carrie Pressley, Donna Daniel, Leslie Prikle, Lensi Hearns, Carla McHinney, Vicky Parks, and Denise Johnson. (Both courtesy of Faye Anderson.)

TRADEMARK OF TRADITION. Each belle is required to buy or make her own antebellum-style dress. Styles are open but have to be a pastel color and cannot be strapless. The hoop dresses have to have pantaloons. Hats or bonnets, along with gloves, are also part of the standard look. Storing items like keys or cell phones have become an issue in recent times, so pockets were added to accommodate modern necessities. Learning standard etiquette of hosting is stressed to prepare the ladies. Beginning in 1995, the Hoover Beautification Board committee started overseeing the selection of ladies and planned activities. Pictured below are Kelley Moorhead Gambrell (left) and Julie Schilleci Foster at the Riverchase Galleria. One big event in 1995 was the homecoming of Miss America Heather Whitestone, who is from Hoover. (Above, courtesy of Faye Anderson; below, Kelley Moorhead Gambrell.)

FIRST HOOVER INDUSTRIAL BOARD. The Hoover Industrial Board was formed in February 1981 to assist businesses in obtaining financing to build their companies in Hoover. This also helped bring in tax-paying industries and job opportunities. Shown here are, from left to right, members David Bradley, Jack Wright, Charles Henderson, Mayor Frank Skinner Jr., chairman John Anderson, and Allen Pate. Not pictured is Gene Powell. (Courtesy of Jack Wright, City of Hoover.)

HOOVER MUNICIPAL BUILDING. On November 24, 1985, the new Hoover Municipal Complex opened. This three-story building was designed by Freeman-Livingston and the architectural firm Adams/Peacher/Keeton and Cosby, Inc. The new building became the home office of the mayor and council and the Hoover City Police Department. Mayor Frank Skinner Jr. gave the dedication address and cut the ribbon. (Courtesy of the City of Hoover.)

THE RIBBON CUTTING. Pictured at left is Mayor Frank Skinner Jr. at the ribbon cutting officially opening the Hoover Municipal Complex. This image was taken just as the ribbon broke away. After, the public was taken on a tour of the facility. Below, just inside the front doors of the municipal complex after the cutting are Hoover's first elected female councilwoman, Faye Anderson, who was also a member of the planning and zoning board, and Hoover City Council president William J. Billingsley. Many attended the grand opening, as it was a community-wide event and open to the public. (Both courtesy of the City of Hoover.)

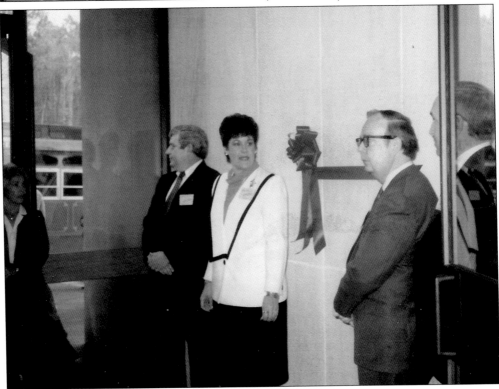

GUEST SIGNING. Guests at the dedication signed in and collected a program outlining the ceremony. Many Hoover residents attended with some even bringing children to the grand opening. These photographs are kept in the guest book, seen here being signed. The guest book is still kept at city hall today as a memento of the celebration and grand opening. (Courtesy of the City of Hoover.)

BELLES HOST OPENING. Pictured are the Hoover Belles at the open house and dedication of the Hoover Municipal Complex. The belles greeted guests and gave tours of the new facility. Shown from left to right are Beth Anderson, Heather Chandash, Sally Sizemore, Kelly Stanford, Melissa Daniel, Mary Page Robertson, Sharon Murton, Kim Hall, Tammy Blake, Melissa Utley, unidentified, Julie Blackmon, Tracy Real, and Joy Little. (Courtesy of the City of Hoover.)

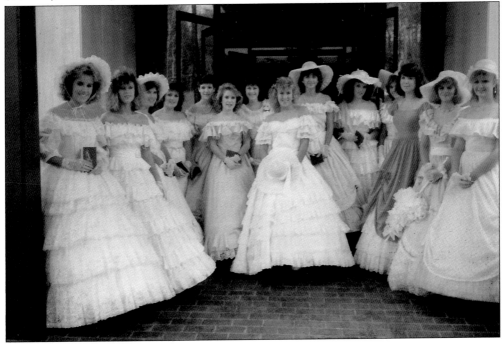

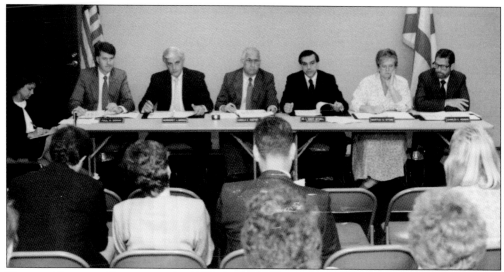

HOOVER BOARD OF EDUCATION. In 1987, the first Hoover City School Board was established for the new school system. Pictured here at the first office on Data Drive are, from left to right, Mary Jo Powell, Paul Doran, Morrisey March, Harold Shepherd, Supt. Bob Mitchell, Martha Stone, and Charles Hickman. This is one of the first meetings the board held. (Courtesy of the Hoover Board of Education Archives.)

A DAY AT THE PARK. In September 1985, the Hoover City Council established and appointed the Hoover Park and Recreation Board, with Councilwoman Faye Anderson as its liaison. The first project for the board was Georgetown Park, and others included Star Lake, which received sidewalks, and Hoover's first off-leash dog park in 2010 at Loch Haven in Rocky Ridge, a popular spot for Hoover's best friends. (Author's collection.)

Six

HISTORICAL HOMES AND NEIGHBORHOODS
STRUCTURES WITH STORY

HOMES OF NOTE. There are several historical homes throughout the city of Hoover. Many are located in the Bluff Park community, such as the Overseer's Home, which is the oldest in Bluff Park, having been built in 1889. Another is the Hale-Joseph Home, pictured here, that was built in 1909. The following homes and neighborhoods represent a sampling of the historic preservation in Hoover. (Courtesy of Susan H.C. Kelley.)

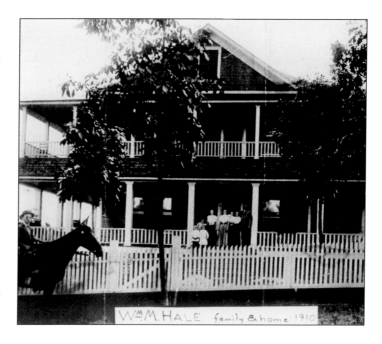

HOUSE KIT. This home in Bluff Park was made from an Aladdin mail-order kit by the Independent Presbyterian Church and the Boy's Opportunity Farm. It was built for O. May Jones and Eva Brakeman. The bedrooms measure 9 feet by 10 feet with closets. In 2010, the home was listed with the Jefferson County Historical Commission as the Children's Fresh Air Farm, Superintendent's Cottage/Doyle Home. (Courtesy of the Jefferson County Historical Commission.)

ROBERT SCOTT TYLER FAMILY HOME. The Tyler family is very prominent in Bluff Park, and Tyler Road is named after them. Robert Scott Tyler built his family home, located at 556 Park Avenue, across from Bluff Park School. Robert's wife, Garnette, is pictured on the steps of the family home. Tyler lived in the house until his death at the age of 90. (Courtesy of Bobbie Tyler Hill.)

MONTE D'ORO. Across Highway 31 and Lorna Road is the neighborhood of Monte D'Oro. Monte celebrates its 50th anniversary in 2014. It consists of 160 homes between Wisteria Drive and the Interstate 459 overpass. Zoning started in 1964, and the last home was built in 1972 on Dundale Road. The subdivision was developed by William H. "Bill" Humphries, who attended the Auburn University School of Architecture. Humphries wanted his homes to be distinctive, with no two alike. He hired Cordray Parker to help design and decorate the homes. Parker was also a well-known artist who studied in Italy and Austria. Parker's works can been seen at the Birmingham Museum of Art and the Botanical Gardens. (Above, courtesy of Monte D'Oro; below, the Hoover Public Library, Hoover, Alabama.)

HOMES OF MONTE D'ORO. Humphries's company office was the home at 3200 Monte D'Oro Drive, which is now the site of a private residence. Humphries lived on Wisteria Drive and later moved to this home, located at 3325 Monte D'Oro Drive. Several streets in this neighborhood have names with Italian translations. Monte D'Oro is Italian for the "Mountain of Gold" and was influenced by designer Parker's time in Italy. (Author's collection.)

BRIDGE TO SUBDIVISION. Across the highway in the Shades Mountain Community is the subdivision of Mountain Oaks, established in the late 1960s. The design and development team of Gerald Smith and Bob Flemming built a covered bridge to mark the area's entrance. The old-fashioned bridge, made of cedar stands, is over Mountain Oaks Drive by a curve near Dartmouth Drive and Mountain Oaks Lane. (Courtesy of Mt. Oaks Garden Club.)

SHADES CLIFF TEA ROOM. Tucked away in Bluff Park is 380 Shades Crest Road, known as the Shades Cliff Tea Room. Original designer Clyde Orr and his wife built their home in 1947. Mrs. Orr ran her tearoom on the bottom floor. Seen above is a side view of the home in 1950. In following years, the home changed ownership from the Orrs to the Barbers, the McCutcheons, and then the Creasons. New exterior paneling was added by current owners Ronnie and Jan Whitworth, who bought the home in 1998. Below is the old garage in 1950 with what looks like Jefferson County Unit 29, of the board of education, parked outside. The garage is the only part of the property visible from Shades Crest Road. The original was taken down, and a new garage was built in 1955. (Both courtesy of Birmingham, Ala, Public Library Archives.)

VIEW WITH YOUR TEA. Orr built the tearoom home with one story facing the road and two stories facing the valley below. Mrs. Orr served lunches and dinners to guests dining with her back in the tearoom days. This aerial photograph shows the rear of the house. The stone porch and veranda columns are also seen. (Courtesy of the Whitworths.)

JARRETT-BLAKE HOUSE. This post–World War II bungalow-style home, Jarrett-Blake House, was built in 1953 at 1501 Berry Road. Longtime owners Clyde and Jane Jarrett passed the house on to son Charles Jarrett in 1970. James and Linda Blake bought the home in 1977. The Jarrett-Blake House was listed with the Jefferson County Historical Commission in 2005. (Courtesy of the Jefferson County Historical Commission.)

A HOME ON THE MOVE. At one point, the Dorah and Mervyn Sterne (of Sterne Agee and Leach Investments) home was the oldest known on unincorporated Shades Mountain. The two-story home is thought to have been built around 1819 by Peter Ingle and moved to 2437 Tyler Road in the 1940s. The Sternes bought the home in the 1950s. After Dorah's death in 1994, the home was rented and then became vacant. In 2004, the 11-acre property was bought by Wedgworth Companies to build Viridian, a green community. The home was beyond repair, but materials were salvaged during demolition and used in the construction of new homes. The property is situated in the middle of Hoover zoning but is part of Vestavia Hills. (Both courtesy of Wedgworth Construction Company.)

PAST AND PRESENTS. This home, now a business, was built in 1929. It was a day care at one time and is now the home of Past and Presents Antiques and Gifts, owned by Jen and Ken Mishalanie. Records of the property show that there was also a chicken house and a wood shed on the property when it was a residence. (Author's collection.)

STONECROFT. John B. and Anne Weakley's home was built between 1921 and 1923 on Shades Crest Road. John, a member of the 1901 Constitutional Convention, also served in the legislature. The Tudor Revival–style home was added to the Alabama Register of Landmarks and Heritage in 1991 and National Register of Historic Places in November 2001. It is also listed with the Jefferson County Historical Commission. (Courtesy of the Jefferson County Historical Commission.)

Seven

CLUBS AND COMMUNITY
CIVIC MINDED AND FAMILY ORIENTED

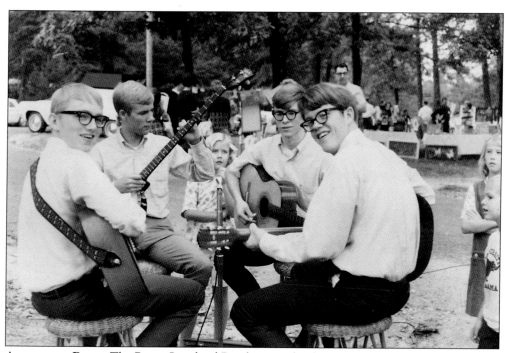

AFTERNOON BAND. The Barry Copeland Band enjoys the day at the first annual Bluff Park Art Show. Pictured are Allen Gillespie, Bill Patton (on banjo), Wheeler Stewart, and Barry Copeland. Half a century later, the show celebrated its 50th anniversary. Today, the show hosts many local and national artists and hundreds of guests each year. (Courtesy of the Bluff Park Art Association, provided by Sally Johnson.)

SHADES CREST AND LOVER'S LEAP. Shown at left in 1916 is Shades Crest Road in Bluff Park. The telephone pole marks the front of Evan Presley Hale's home, and the sidewalk is near William Marable Hale's home. Both homes still stand today, although the once-dirt road is now paved. A large set of limestone boulders on the crest is the well-known "Lover's Leap." The rock formation is along Shades Crest Road near the Tip Top Grill. Part of the story dates back to 1827, when Alabama legislator Thomas W. Farrar came to the area and camped with his wife for several days. Pictured below in 1909 are Homer Hurd and Irene Copeland visiting Lover's Leap. (Both courtesy of Susan H.C. Kelley.)

THE TRAVELING ROCK. When Thomas W. Farrar made a trip to the site, he carved the first four lines of *Childe Harold's Pilgrimage*, a poem by Lord Byron. Farrar later founded and served as grand master of the first Masonic lodge in Alabama. In the early 1930s, the original inscribed rock was removed and presented as a gift to the Masonic lodge in Elyton, named after Farrar. In 1982, the original rock was moved to the McCarty-Farrar Lodge in Mt. Olive, Alabama, where it was proudly displayed. Shown here is the original rock with the original inscription on display in Mt. Olive. (Courtesy of the Whitworths.)

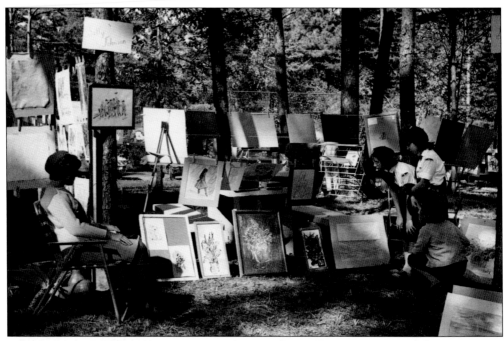

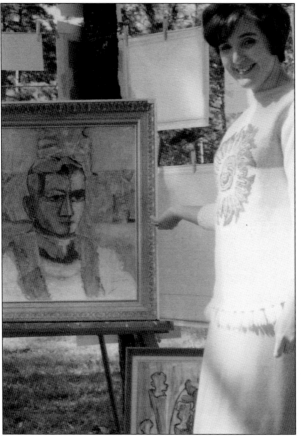

BEGINNINGS OF THE BLUFF PARK ART SHOW. In 1963, a group of parents from Bluff Park Elementary School sponsored a "Come As Your Favorite Book" dance as their first fundraising project in hopes of expanding the school library. Then, in 1964, an art auction was held, and artists in the community contributed their paintings and crafts, adding $850 to the library fund. In 1965, the group formed a nonprofit corporation and held a second art show. This show had 65 artists participating. Shown above, sitting with her art at the 1965 show, is Sally Johnson, one of the charter members. Johnson is also seen at left with her painting *Vicar of St. Albans.* (Both courtesy of Bluff Park Art Association, provided by Sally Johnson.)

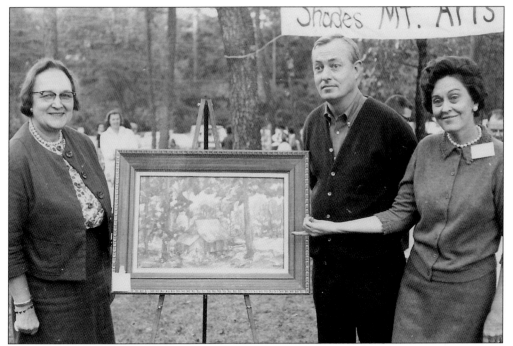

FIRST-PLACE ART. Pictured here with the first-place art show painting in 1965 are, from left to right, Helen Stephens, Henry Kimbrell, and Dot Copeland. The painting, *Cabin on Sanders Road*, was painted by Kimbrell. It was displayed in Bluff Park Elementary School and is now part of the permanent collection of the Bluff Park Art Association. (Courtesy of Bluff Park Art Association, provided by Sally Johnson.)

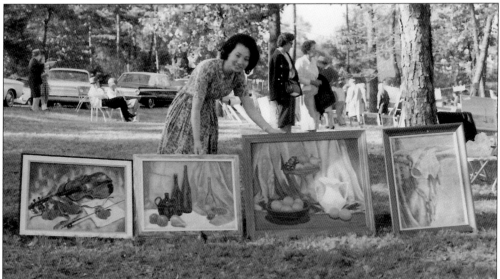

ART ICON. One cannot talk about art in Bluff Park without including resident Soon-Bok Lee Sellers. Today, the Artists on the Bluff facility in Bluff Park hosts the Soon-Bok Lee Sellers Art Gallery, where works from local artists and traveling shows are displayed. Pictured here at the Bluff Park Art Show in 1965 is Sellers displaying her works. (Courtesy of Bluff Park Art Association, provided by Sally Johnson.)

THE GARDEN VISION. In 1966, Eddie Aldridge, a noted horticulturalist, saw property owned by John Coxe and instantly recognized potential for botanical gardens. In 1978, Aldridge ran into Floyd Wallace, who worked for Coxe. Wallace told him the property was being sold. If not for Wallace, the gardens may not have happened. Pictured here in 1964 is Wallace stocking the lake at the property with fish. (Courtesy of Aldridge Gardens.)

TRANSFORMATION. Mrs. Coxe sold the property to Aldridge. In 1994, the transformation to a public garden began. The land was formally dedicated as a public garden, and a resolution was passed to ensure it remained so. A master plan was approved in 1997. In June 2002, Aldridge Botanical Gardens opened. Aldridge's trademark snowflake hydrangeas flourish in the garden with many other local flora. (Courtesy of Aldridge Gardens, photograph by Larry O. Gay.)

HOME AND LAKE. The home on the Aldridge Botanical Gardens property is the original Coxe family home. Designed in 1964 by Birmingham architect Henry Sprott Long, it overlooks the lake. A waterfall named for Kay Aldridge flows 150 feet to the lake. Aldridge Botanical Gardens has been in found *Southern Living* magazine on numerous occasions, and the snowflake hydrangea was designated Hoover's official city flower. (Courtesy of Aldridge Gardens, photograph by Larry O. Gay.)

CITY BIRTHDAY. Even a city needs a cake on a milestone birthday. Hoover celebrated its 20th birthday on May 23, 1987. There were many activities at the celebration held at city hall, including multiple cakes from area merchants and one big cake on display on the front lawn. The city of Hoover is a few years away from its 50th anniversary (in 2017). (Courtesy of the Hoover Public Library, Hoover, Alabama.)

HOOVER OASIS. Star Lake and Park is one of Hoover's oldest lake and park sites. The four-acre lake is a favorite place for residents. John Baird Contracting Co. developed Star Lake and the infrastructure for the subdivisions around Hoover Country Club. Wayne Thompson, affectionately known as "the duck man," fed the ducks at the lake for over 30 years. Both Thompson and Baird passed away in 2014. (Author's collection.)

LAKE FACE-LIFT. After 30 years, the lake needed some help as it had become full of silt and slithering inhabitants. In 2001, the City of Hoover began dredging; part of the project included making the lake deeper. Using earthmovers and a tractor with a 60-foot reach, city workers dredged below the remaining water level after partially draining it to make it 16 feet deep. (Courtesy of Jack Wright, Hoover City Council.)

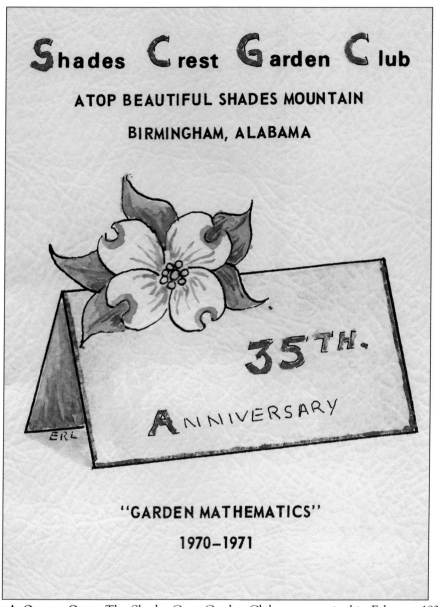

HOOVER'S OLDEST CLUB. The Shades Crest Garden Club was organized in February 1935. A group of 12 women were at the first meeting at the home of Mrs. Lauden Coats, who lived on Shades Crest Road. The meeting was to discuss starting a neighborhood garden club. One of the first civic projects the club worked on was getting the county to clear some underbrush in the area to protect from fire. The club also designed the landscaping around the Bluff Park/Crawford Fire Tower that once stood on the crest. A handcrafted wooden box was made to hold the club's membership books, like the one pictured here from 1970. The box serves as a time capsule to hold the memories of the club. Members also did many projects to beautify the mountain. Approximately 140 dogwood trees were planted, overgrown rose bushes from the Linger Longer Lodge were moved to be planted along the road, and a nursery donated 500 crepe myrtles for the club to plant. In 1985, the club celebrated its 50th anniversary as a federated garden club. (Courtesy of Hoover Historical Society.)

THE HOOVER SERVICE CLUB. At age 82, Flora Mae Pike set out to create a club dedicated to helping others. With the assistance of Pat Vaughn, 10 ladies met at the home of Mary Lou Woolley to discuss the possibility of creating a club. On May 5, 1975, the Hoover Service Club was formed. The first membership coffee was held at the home of Pat Vaughn in October 1975. At left is a Hoover Service Club members' book dated 1976. The membership fee was $4. In 2005, the club celebrated its 30th anniversary—"Celebrating a Legacy"—at Aldridge Gardens. A silverbell tree was planted in commemoration. In the photograph below, five charter members are being honored; pictured are Ruth Gibbs, Pat Vaughn, Polly Cox, Elsie Braddock, and Julia Hoover. (Both courtesy of Hoover Service Club.)

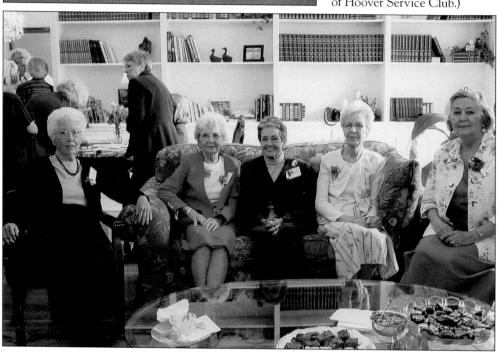

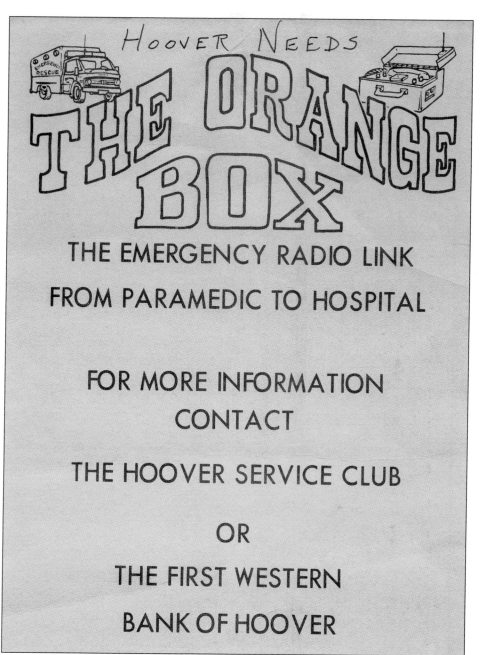

HOOVER NEEDS

THE ORANGE BOX

THE EMERGENCY RADIO LINK
FROM PARAMEDIC TO HOSPITAL

FOR MORE INFORMATION
CONTACT

THE HOOVER SERVICE CLUB

OR

THE FIRST WESTERN
BANK OF HOOVER

A Big "Orange Box." The first major project for the Hoover Service Club was to raise funds to purchase a Biophone, or an "Orange Box," for the volunteer fire department. The Orange Box was advanced life-support equipment for the department. The device, a voice and telemetry radio communications system, was used by paramedics to communicate with the hospital physician. The small group of members sought donations from neighbors and friends and placed donation boxes in local stores; soon, the group had raised sufficient funds to purchase the box. The mission of the club was and still is to be civic spirited, religiously activated, and benevolently motivated. In its 30 years of existence, the membership of the Hoover Service Club has been open to all Hoover residents. (Courtesy of Hoover Service Club scrapbook, Hoover Historical Society.)

GOLF CLUB. Bill Hoover was the avid golfer of the Hoover family, but his father saw the appeal of a club/course and how it would encourage residential growth. The beginnings of Green Valley–Hoover Country Club dates back to a meeting in 1958 with an organizing board of governors and William Henry Hoover Sr. W. Bancroft Timmons, along with Paul Stapp and Vic Goodwin, designed the front nine, which opened in 1961, and then the original clubhouse and pool in 1962. Bermuda grass was planted, and a pump house was constructed to pump water from Star Lake. George Cobb designed the back nine, pictured below, and it opened in 1963. In 2007, the club held its first annual Night of Champions and inducted Steve Lowery to the first Wall of Champions. (Both courtesy of Hoover County Club.)

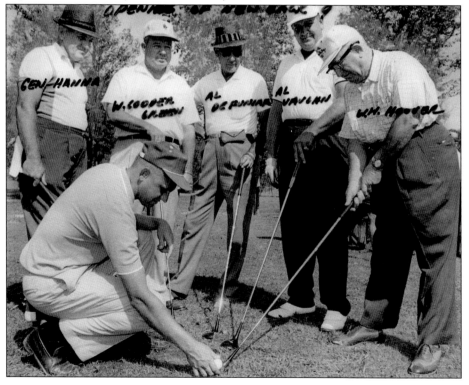

LPGA IN HOOVER. The Birmingham LPGA Classic was the social event when the club hosted it between 1972 and 1982. Betty Burfeindt was the inaugural championship winner. Jane Blalock, pictured here, was the only two-time winner; her first came in 1974, and the second in 1979. Maria Astrologes made a hole-in-one on one of the club's toughest holes and won in 1975. (Courtesy of Hoover Country Club.)

LINGER LONGER LODGE. The lodge was a private social club from the 1920s to the 1940s and was known for glamorous evenings and shady gambling and drinking. In the 1930s, the name became the Blue Crystal. In 1968, the lodge (then a residence) was demolished, making way for Interstate 65. Shades Crest and Berry Roads were redirected. The lodge may be gone, but a Geocache marks its location N 33°25.965W086°49.509. (Courtesy of Hoover Historical Society.)

Linger Longer Festival

Linger Longer Lodge
1920-1968

THE GENERAL FEDERATION OF WOMEN'S CLUB. In 1971, the Shades Mountain Junior Woman's club organized with the motto "Happiness consists in doing all the good we can even in small ways." Charter members included Dena Bowden, Marge Gower, Irene Hall, Clara Lamb, Annette McDuff, Alice Moore, JoAnn Russell, Fran Scott, Elease Smith, Jane Ann Swearingen, and Jo Beth Wheaton. Shown above in 1977 is charter member Elease Smith with Mrs. Sullivan, Mrs. McClain, and Mrs. McFalls. The Hands on Art for Children booth started in 1978 at the Bluff Park Art Show as a place for children to make a take-home art project. In 1996, the club dropped "Junior" from its name. The club has offered services in education, home life, health issues, and international outreach. (Both courtesy GFWC Shades Mountain Women's Club.)

MONTE DE FLEUR. In the neighborhood of Monte D'Oro, the ladies of the community established the Monte de Fleur Garden Club in 1971 with 16 charter members. This group met in the daytime, and a second group that functioned side by side, called the Monte D'Oro Planters, met at night to have the clubs available at different times to coordinate with residents' schedules. Pictured at right is the charter members listed on the Alabama Garden Clubs certificate, and below is one of the first membership booklets of the Monte de Fleur Garden Club from 1972 to1973. (Both courtesy of the Monte D'Oro Neighborhood Association.)

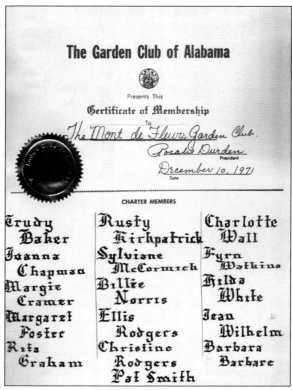

The Garden Club of Alabama

Presents This

Certificate of Membership

To The Mont de Fleurs Garden Club.
Rosald Durden
President
December 10, 1971
Date

CHARTER MEMBERS

Trudy Baker
Joanna Chapman
Margie Cramer
Margaret Foster
Rita Graham

Rusty Kirkpatrick
Sylviane McCormick
Billie Norris
Ellis Rodgers
Christine Rodgers
Pat Smith

Charlotte Wall
Fyrn Watkins
Hilda White
Jean Wilhelm
Barbara Barbare

Mont de Fleurs
GARDEN CLUB

BIRMINGHAM, ALABAMA
1972-1973

WOMEN'S CLUB LEADERSHIP. The Monte de Fleur Garden Club became the Monte D'Oro Women's Club in 1976. Shown at left in June 1980 are the newly installed officers. From left to right are Mrs. Jamison, Mrs. Brown, Mrs. Suschak, Mrs. Medlyn, and Mrs. Pike. Pictured below are the officers for the 1982–1983 Monte D'Oro Women's Club. From left to right are Lynn Pike (president), Frances Thompson (first vice president), Janet Richardson (second vice president), Lou Thorn (treasurer), and Loretta Barber (secretary). The clubs became today's Monte D'Oro Neighborhood Association. The association promotes beautification and pride of personal property, with no covenants, and encourages beautification and communication on anything that would detract from property value. Preserving the history and integrity of Monte D'Oro is also one of the top goals of the association. (Both courtesy of Monte D'Oro Neighborhood Association).

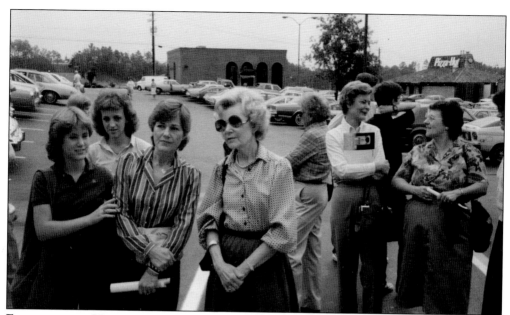

FRIENDS OF THE HOOVER LIBRARY. When the Hoover Public Library became a reality, it was a testament to the will of a community and what they can do together. The board of trustees of the Hoover Public Library hosted a preview reception on October 2, 1983, at the new library location. Charter members of the Friends of Hoover pictured here are, from left to right, Ruth Ann Poynter, Marge Satterwhite, Sylvia Swaim, and Anne Sammons. (Courtesy of the Hoover Public Library, Hoover, Alabama.)

COOKBOOKS FOR FUNDS. The Friends of the Hoover Library sponsored two major fundraising events in the community: selling a cookbook by Sue Murphy and a "tasting fair" featuring many of Murphy's recipes. Tickets to the fair were $3 each, and the cookbooks sold for $3.50. Pictured here are Mary Lou Allen (left) and cookbook author Sue Murphy. (Courtesy of the Hoover Public Library, Hoover, Alabama.)

MOUNTAIN OAKS GARDEN CLUB. Serving many needs, this club's projects included raising money to pay for an underground water system for Shades Mountain Elementary School. The club also made repairs, with David Strickland, to the covered bridge leading into the community. Another event was a fashion seminar with Audrey Lindquist at Mary Reed's home. Pictured here are, from left to right, June Romero, Janice Adams, and Pam Weidenback. (Courtesy of Mountain Oaks Garden Club, Hoover Historical Society.)

STAR LAKE GARDEN CLUB. Organized and federated in June 1961, an exploratory meeting was held in the home of Mrs. Lewis and orchestrated by Mary White. The group wanted to utilize the art of gardening and encourage beautification of the community. In 1973, the club began planting and caring for Star Lake. Shown here in 1979 are members during a workday at the lake. (Courtesy of Star Lake Garden Club, Hoover Historical Society.)

IN PARTING. To close this journey and sampling of Hoover's history, it is important not to forget where the city came from to appreciate where it is today. This plaque erected by the Alabama Tourism Department was placed at city hall in 2010. The city received recognition from *Money* magazine as one of the top places to live in America. The City of Hoover has seven city council members elected at-large on a nonpartisan basis. Pictured below in council chambers are the 2013–2014 Hoover City Council and mayor. From left to right are (first row) council president pro tem Brian Skelton, Mayor Gary Ivey, and council president Jack Wright; (second row) councilmen Rear Adm. John T. Natter, USN (Ret.), John Greene, John Lyda, Gene Smith, and Dr. Trey Lott. (Both author's collection.)

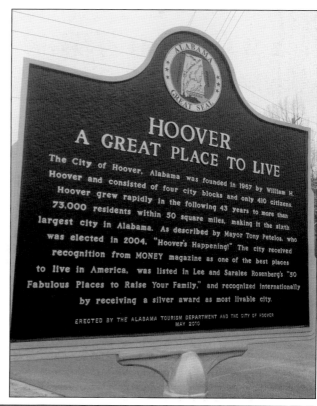

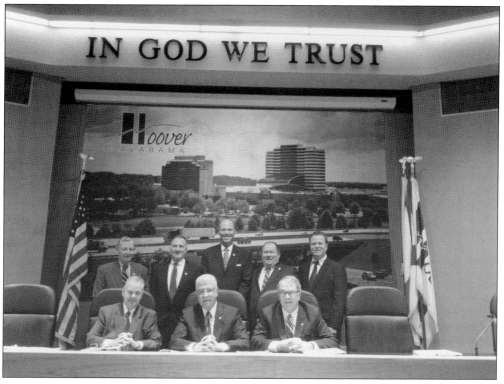

BIBLIOGRAPHY

Aldridge, Eddie. *Garden of Destiny*. Hoover, AL: Seacoast Publishing, Inc., 2009.

Patterson, John and Bill Ainsworth. *A History of Hoover Baptist Mission*. Birmingham, AL: Green Valley Baptist Church archives, 1969.

Thompson, Ian. *From Green Valley to Hoover Country Club (Fifty Years of Memories)*. Virginia Beach: The Donning Company Publishers, 2010.

Wood, Wayne. *Bob Finley: A Class Act. The Life and Influence of a Great Coach and Teacher*. Hoover, AL: The Finley Company, 2003.

ABOUT THE ORGANIZATIONS

Established in 1983, the Hoover Public Library's purpose is to meet the needs of the citizens of Hoover through its services, resources, and facilities. Ranked third in the state in circulation, it is the only single-unit library in Alabama to achieve such a high ranking. For more information, visit www.hooverlibrary.org or call 205-444-7800.

Bluffparkal.org first went online in August 2006. The site delivers events, happenings, and information about Bluff Park, Alabama. The site is maintained locally, thus the slogan, "For, about and by Bluff Park, Alabama."

Discover Thousands of Local History Books
Featuring Millions of Vintage Images

Arcadia Publishing, the leading local history publisher in the United States, is committed to making history accessible and meaningful through publishing books that celebrate and preserve the heritage of America's people and places.

Find more books like this at
www.arcadiapublishing.com

Search for your hometown history, your old stomping grounds, and even your favorite sports team.

Consistent with our mission to preserve history on a local level, this book was printed in South Carolina on American-made paper and manufactured entirely in the United States. Products carrying the accredited Forest Stewardship Council (FSC) label are printed on 100 percent FSC-certified paper.

MADE IN THE USA